Underwater Eden

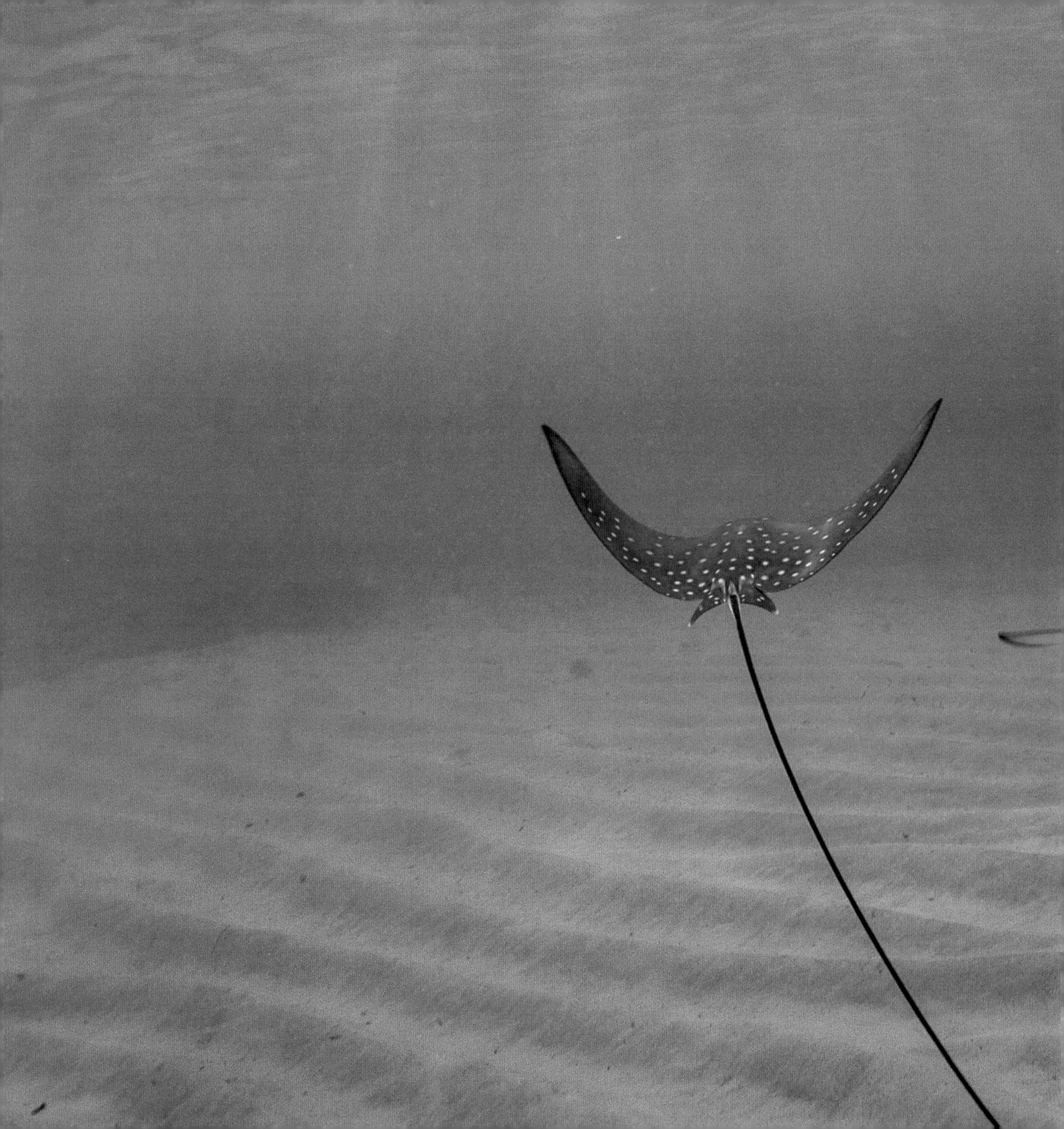

Underwater Eden
The Marine Life of Seychelles

CHRISTOPHE MASON-PARKER & JOE DANIELS

JOHN BEAUFOY PUBLISHING

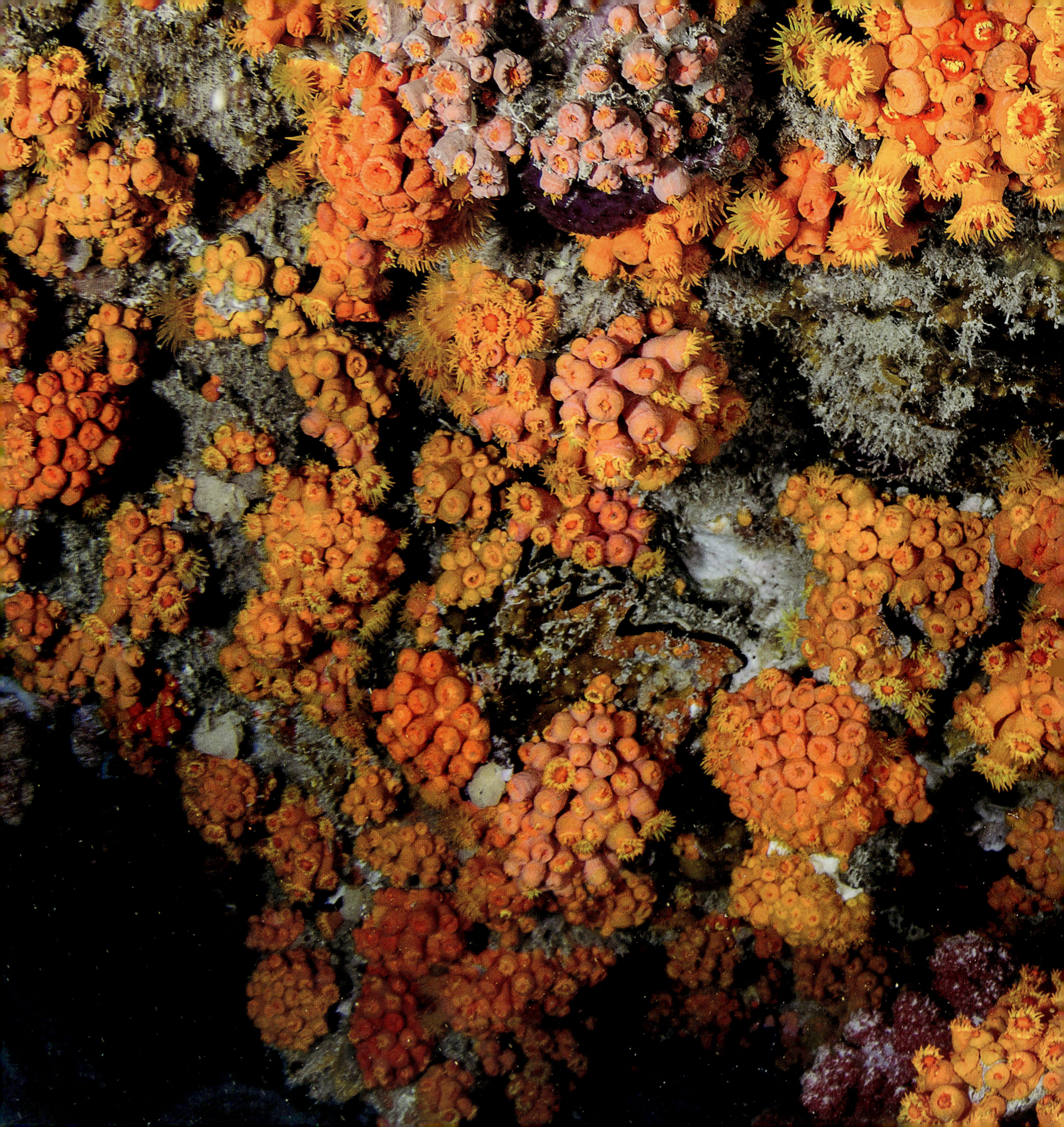

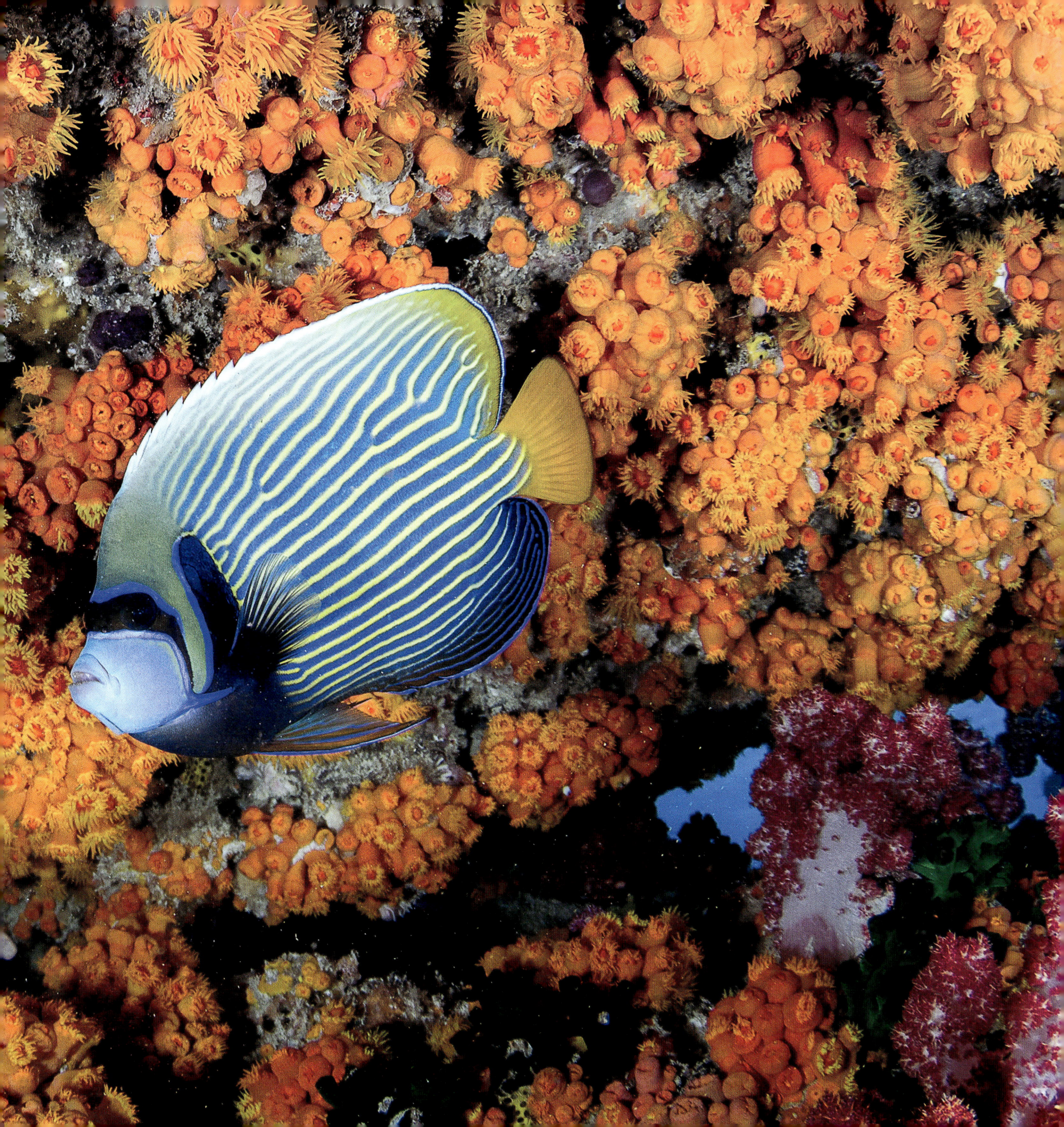

Foreword 8

Introduction 10

Ecosystems 26

Turtles 72

Fishes 92

Invertebrates 136

Marine Protected Areas 164

Conservation 184

Glossary 204

Shooting Eden 205

Acknowledgements 222

About the Authors 223

Left: Anthias are some of the most colourful and abundant fish to be found on Seychelles' coral reefs.

Previous pages: An Emperor Angelfish swims past a granite boulder covered in *Tubastrea* corals. *Tubastrea* is a cup coral that lacks zooxanthellae and relies on plankton feeding, and therefore can often be found under rocks and in caves away from direct sunlight.

Title pages: A pair of Eagle Rays glide under the setting sun in the shallow waters of Glacis, Mahé.

FOREWORD

The Seychelles islands are well known for their exceptional landscapes and seascapes, turquoise waters and white sandy beaches – the picture-perfect destination for discerning visitors. Beyond all this, however, there is much more to Seychelles, particularly in regard to its natural environment. Together with Madagascar, Mauritius, Reunion Island and Comoros, Seychelles belongs to the Western Indian Ocean marine ecoregion. The waters of this ecoregion are rich, diverse and distinct.

The Seychelles archipelago consists of 115 islands scattered over 1.37 million square kilometres of sea and ocean, a combination of granitic and coralline islands and raised atolls. This means that 99 per cent of the Seychelles territory is marine – a vast area consisting of a submerged subcontinent, countless seamounts, ridges, deep canyons and trenches, all contributing to a very rich and diverse marine environment. To the south, the Seychelles waters border the biodiversity-rich Mascarene plateau and are influenced by the Mozambique current, which further contributes towards the enrichment of its waters. The atolls of the Farquhar and Aldabra groups, with their large lagoons and shallow coastal fringes, provide exceptional conditions for marine life to flourish.

Unfortunately, these wonders are today under major threat. Pollution, overfishing, illegal and unregulated fishing, ocean acidification and climate change are all threatening the health of the marine environment and its biodiversity. Land-based pollution and marine litter are on the increase and reach places where no humans venture. Of all the pollutants, plastics seem to be the most damaging, killing scores of seabirds, marine mammals and sea turtles every year. On 30 August 2017, Seychelles joined the ranks of countries that have banned the importation, sales and utilization of plastic carrier bags, Styrofoam takeaway boxes, bowls, plates and cups, as well as single-use plastic cups and utensils.

To tackle the problem of overfishing, the government is working with its partners to develop and adopt a sustainable fisheries plan for the Mahé Plateau. It is expected that the plan will be

ready by the end of 2017. The government is also working – within the framework of the Indian Ocean Tuna Commission – towards a better management of the tuna stock in the Indian Ocean.

Of special importance is the huge progress that Seychelles has made towards managing its waters and contributing to ocean governance within the Western Indian Ocean. Back in 1972 it was the first country in the region to legally create and declare a marine national park. Since then, 26 Marine Protected Areas have been created and put under various management regimes. In 2015, Seychelles successfully closed a Debt for Conservation and Climate Adaptation swap with the Paris Club, which led to the creation of SeyCCAT, a trust fund set up to finance marine conservation and support livelihoods linked to the coastal and marine environment. As part of the debt swap, Seychelles was able to mobilize funding to finance an ambitious Marine Spatial Plan (MSP) for its marine territory, which will underpin its Blue Economy roadmap. The first phase of the MSP will be complete by the end of 2017, subsequent to a comprehensive consultative and participatory process. The rest will be complete by 2020, when it is expected that 30 per cent of the Seychelles marine territory will be declared as protected areas to mitigate against climate change and protect key biodiversity.

This book provides a valuable insight into the inner world of the flora and fauna inhabiting the marine ecosystems of Seychelles, much of which faces an uncertain future. It documents the numerous challenges facing the nation in managing its marine environment, and highlights the innovative work being undertaken by the Seychelles government and conservation practitioners to find practical solutions. The photographs wonderfully portray a diverse world full of beauty, which is available to any who wish to discover it. I hope that the stunning images contained within the following pages will inspire many more people to dive under the waves and explore this 'underwater Eden'.

Mr Didier Dogley, Minister of Tourism, Civil Aviation, Ports and Marine

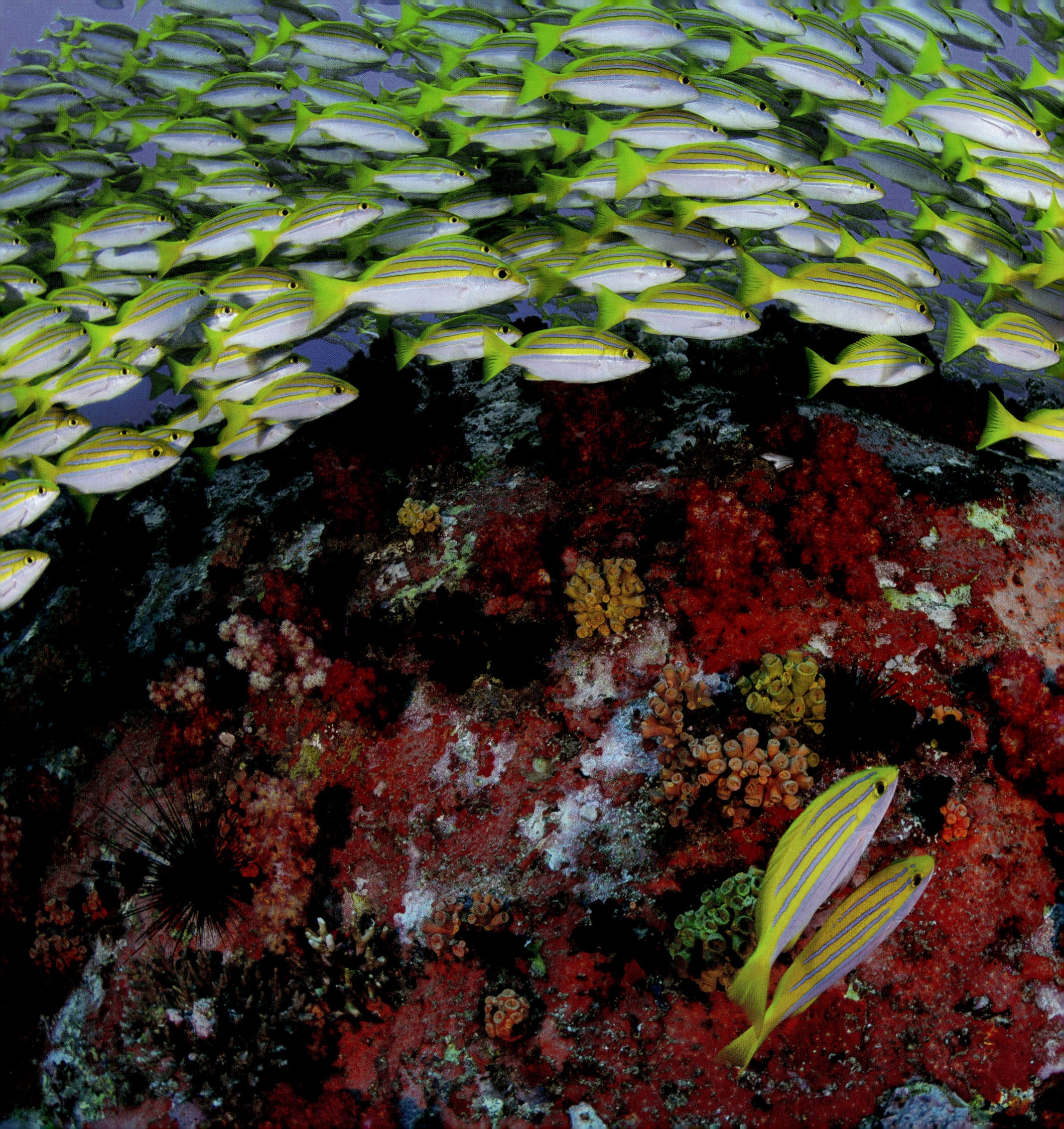

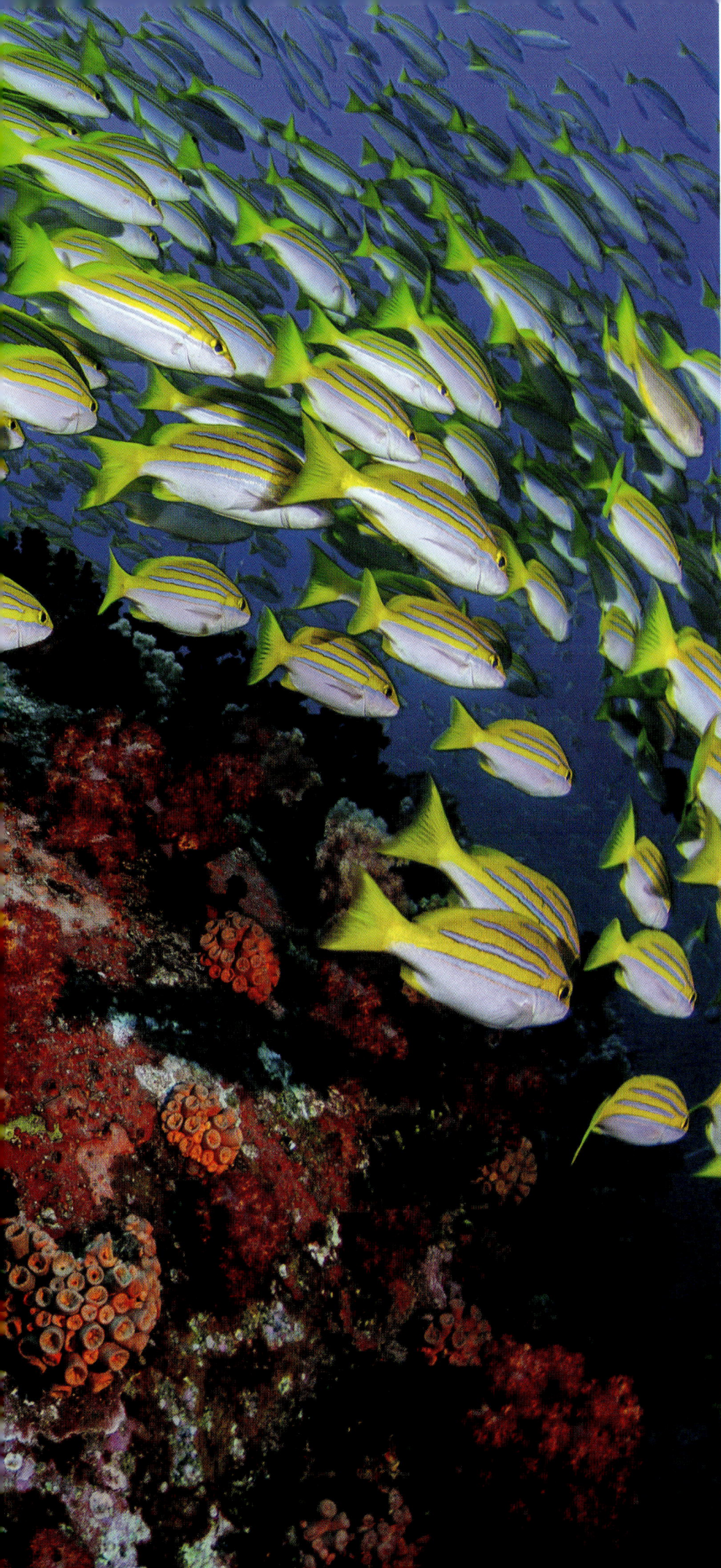

INTRODUCTION

The biblical Garden of Eden is described in Genesis as an unspoilt paradise, notable for containing both the tree of knowledge and the tree of life. For centuries its location has been the basis of considerable discussion, with many religious scholars believing it to be in the Middle East, near the confluence of the mighty Tigris and Euphrates rivers. In the nineteenth century, the British army officer General George Gordon arrived on Praslin Island in Seychelles and, upon visiting the Vallée de Mai with its magnificent Coco de Mer trees, was convinced he had found the true site of the garden. His fervour was based on the suggestive shape of the Coco de Mer nut, which he considered to be the forbidden fruit that had provided Adam with such unenviable temptation. While his beliefs may have been fanciful, perhaps General Gordon was not so far from the truth. Had he decided to peek beneath the surface of the waters that surround Praslin or any of Seychelles' 115 islands, he would have had a tantalizing glimpse of coral gardens teeming with life and mesmerizing in their beauty – truly an underwater Eden.

Left: Thousands of Bengal Snapper school over granite boulders covered in vibrant soft corals.

INTRODUCTION

The Seychelles islands have a total land area of 455km² (175 sq miles) and are scattered across the Western Indian Ocean, within an Exclusive Economic zone (EEZ) of more than 1.37 million square kilometres (386,102 sq miles). They are divided into two distinct regions, which lie between 4 and 10 degrees south of the equator – the inner and outer islands, with 43 islands comprising the inner island group. All but two of the inner islands are granitic, with the remaining pair being coralline. They cover a total land mass of 274km² (105 sq miles), which represents 54 per cent of the nation's land area. Despite accounting for only half of Seychelles' land mass, the inner islands are home to 99 per cent of the archipelago's human population, the majority of which inhabits the three islands of Mahé, Praslin and La Digue.

The Seychelles' granitic islands are of particular geological interest, as they are the only mid-oceanic islands of their kind. While most oceanic rocks are basaltic, Seychelles' granitic islands are more than 65 million years old, and were formed as a result of the fragmentation of the supercontinent Gondwanaland. Following the separation of Madagascar and Australia, Seychelles split from India 60 million years ago and has remained in isolation ever since.

By contrast, the outer islands of Seychelles consist of five separate groups of coralline islands at various stages of formation. With a total land mass of 211km² (81 sq miles) they account for almost half of the land mass within the archipelago. However, due to their remoteness and a scarcity of fresh water, they are home to less than 1 per cent of the nation's population.

While the individual groups of outer islands are spread far apart, those within the granitic cluster are found within 55km (35 miles) of each other. Mahé, home to the capital city of Victoria and the majority of the nation's inhabitants, also has the highest peak, Morne Seychellois, which stands at 905m (2,969ft) tall. The coralline islands could not be more different, with many having a maximum elevation above sea level of only a few metres.

The warm, shallow waters that surround Seychelles' islands provide the ideal conditions for coral growth. Together with adjacent mangrove forest and seagrass beds, these coral reef habitats support a huge diversity of marine life, with more than 800 reef-associated fish species and 50 genera of coral identified.

Two distinct seasons, driven by the prevailing trade winds, affect these shallow coastal waters. The south-east season, which runs from May to October, is characterized by strong winds and rough seas. During

Right: A snorkeller is dwarfed by the immense Whale Shark beside him. This individual is only a sub-adult measuring at around 5m (16ft). Mature Whale Sharks can measure up to 18m (59ft) in length.

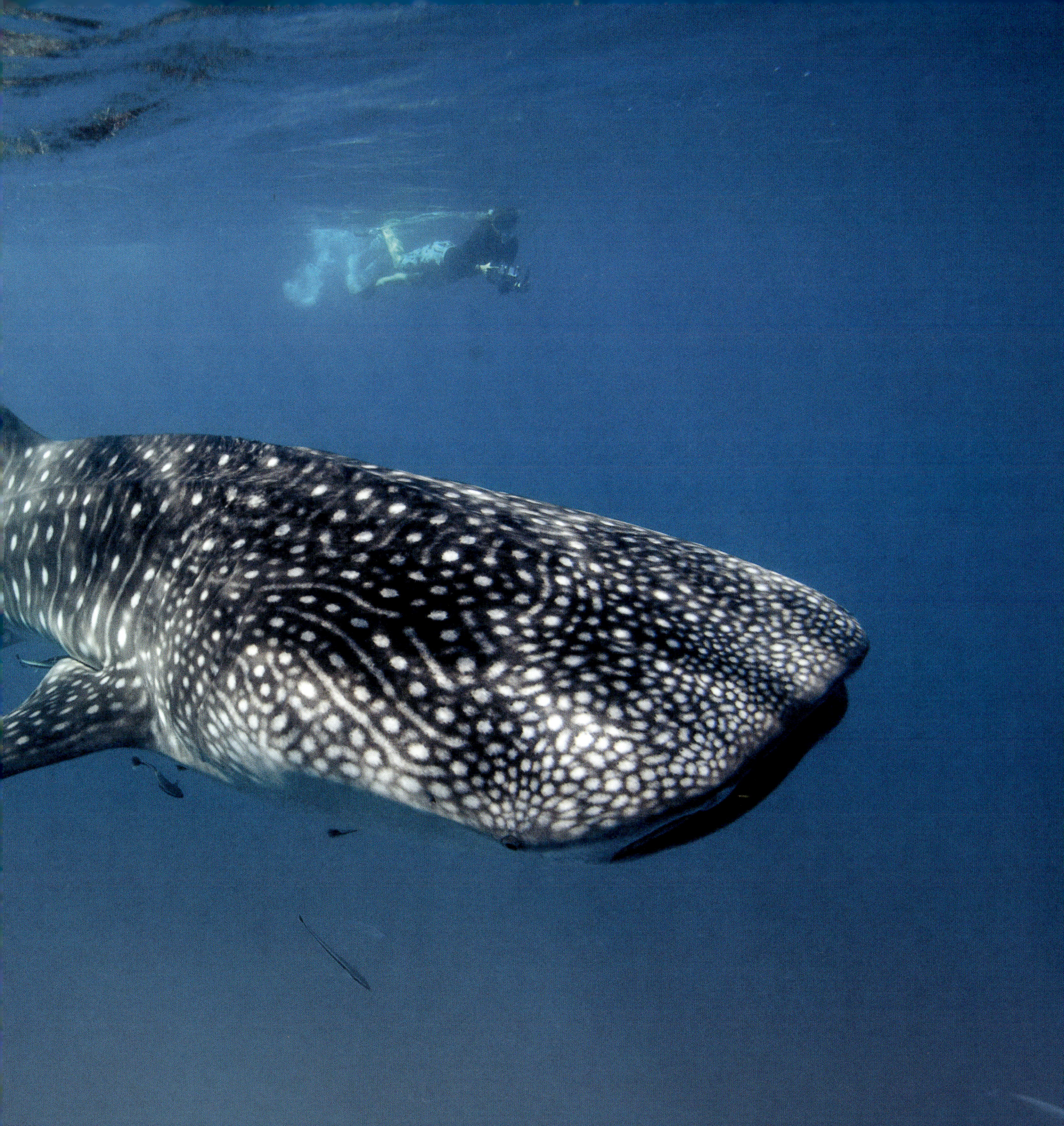

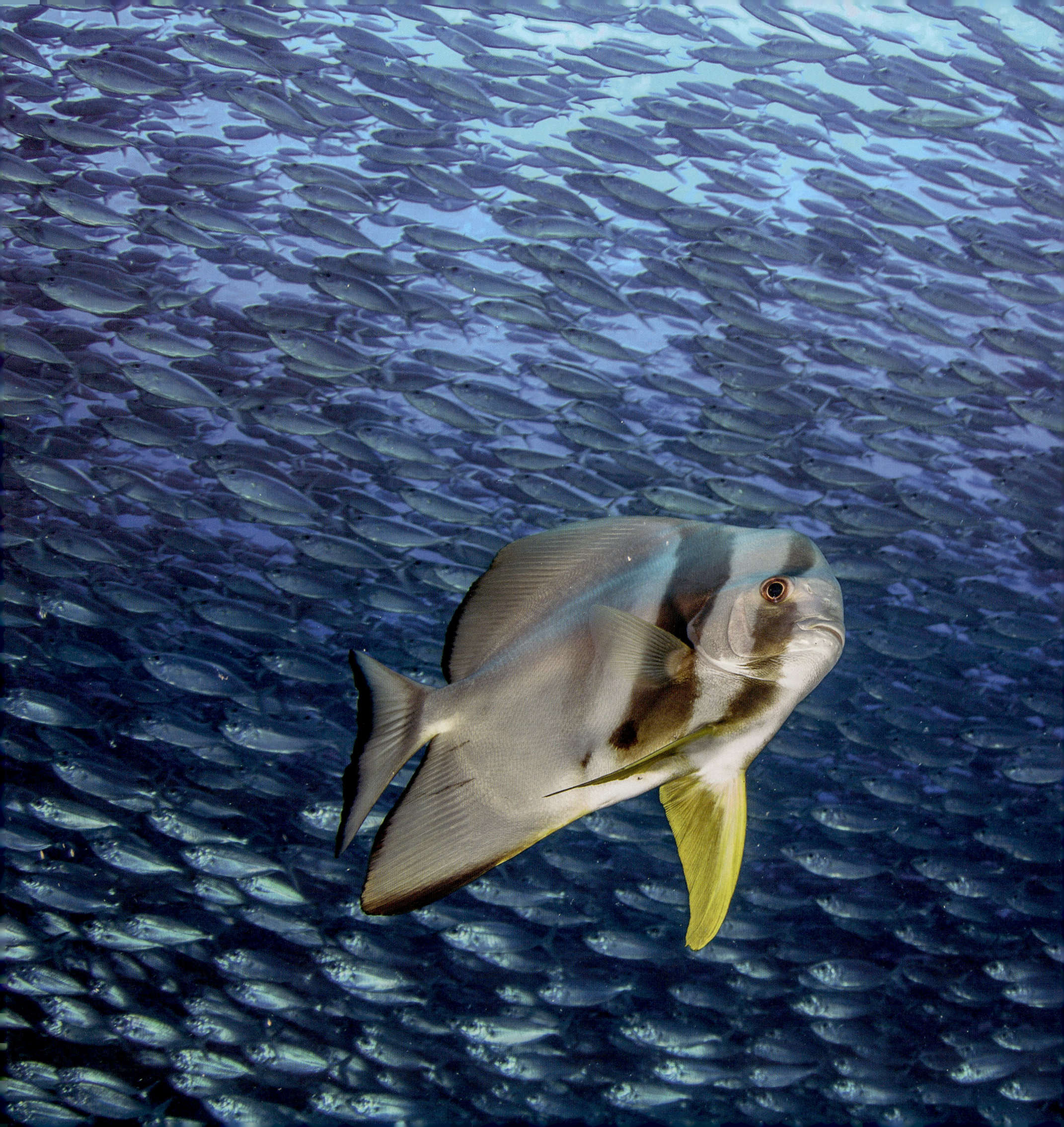

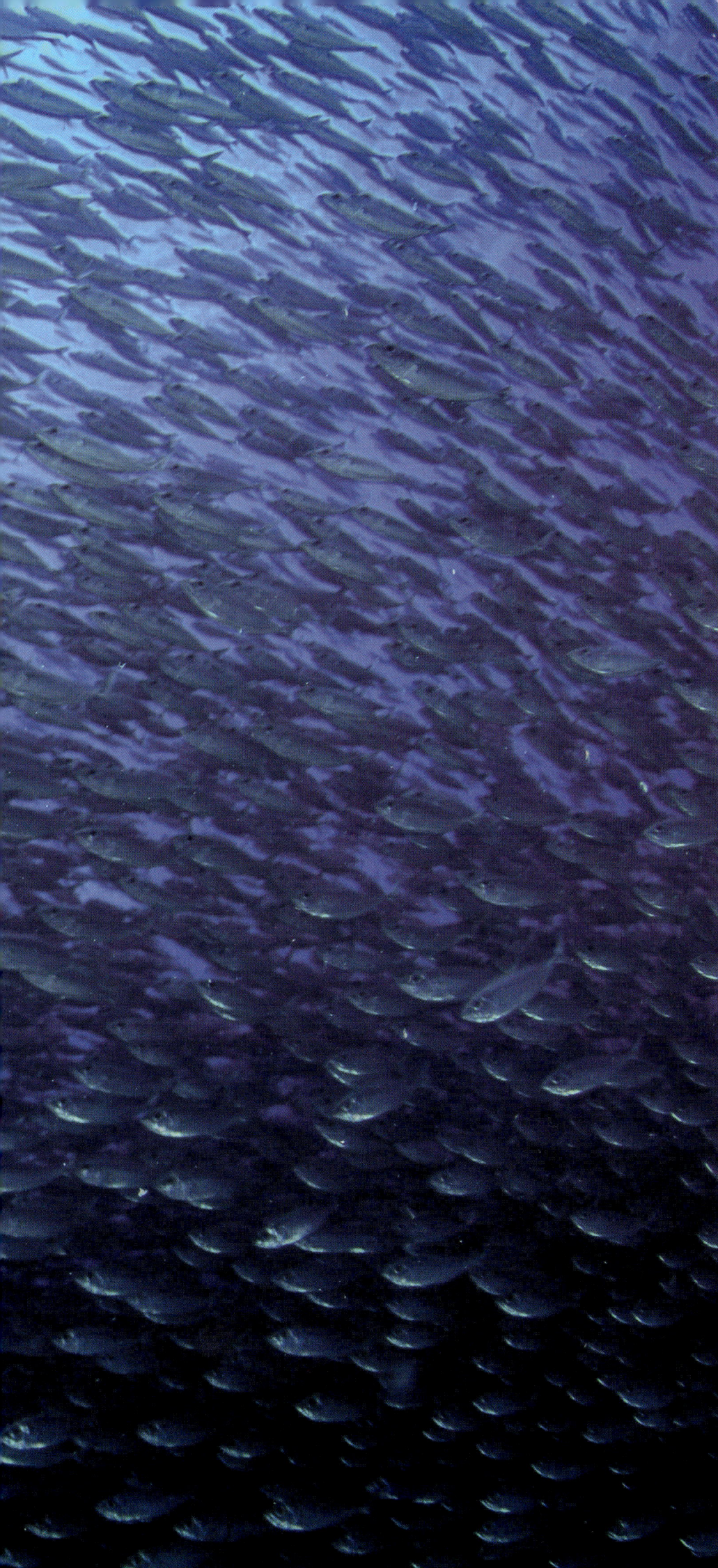

INTRODUCTION

this time cold upwellings deliver plankton-rich water to the islands' shores. From November to April, the north-west trade winds bring a period of heavy rain and calmer seas.

Regardless of the season, the marine environment is inextricably linked with the two pillars of the Seychelles economy. Industrial fishing is the highest source of revenue, while the tourism sector, through direct and indirect employment, accounts for more than 40 per cent of the national workforce. The Seychelles government is keen to capitalize on the huge economic potential of the country's EEZ. The Blue Economy concept seeks to implement a marine-based roadmap for the sustainable use of its resources, and is already developing a nationwide aquaculture masterplan, to run alongside oil and gas exploration, bio-prospecting and other ocean-based activities. The government is aware that the need for food security, economic diversification and job creation should not be at the expense of the marine environment, and as part of an ongoing marine spatial planning process, 15 per cent of the EEZ is to be set aside as no-take areas.

Despite this environmental awareness, the coastal waters surrounding the islands of Seychelles are under increasing pressure from natural and anthropogenic threats. The islands' population continues to grow, which along with rising tourist numbers is placing further pressure on resources, and increasing the need to tackle issues such as waste disposal and habitat degradation. The challenge Seychelles faces will be to facilitate economic development without compromising the nation's environmental integrity. Beyond immediate control are the numerous impacts associated with global climate change. Sea-level rise, coastal erosion and coral bleaching are already having an effect on the islands, placing Seychelles at the forefront of the global climate change stage, and underlining the necessity to urgently engage in risk reduction and climate change adaptation initiatives.

Underwater Eden is a window into the marine realm of the Seychelles archipelago, a small yet timely photographic record captured during a period of uncertainty. It showcases a mere fraction of the incredible diversity of life that inhabits the Seychelles' vast EEZ – without ignoring the innumerable threats that it faces today. The book features a range of species, from mighty plankton-feeding Whale Sharks to tiny nudibranchs smaller than a pinhead. It highlights the current initiatives taking place to protect the coastal environment and the issues at the forefront of marine conservation. Obtaining the images entailed spending hundreds of hours underwater, and involved countless incredible encounters with Seychelles' ocean residents.

Left: A solitary Orbicular Batfish (*Platax orbicularis*) swims against a backdrop of swirling mackerel at Marianne Island.

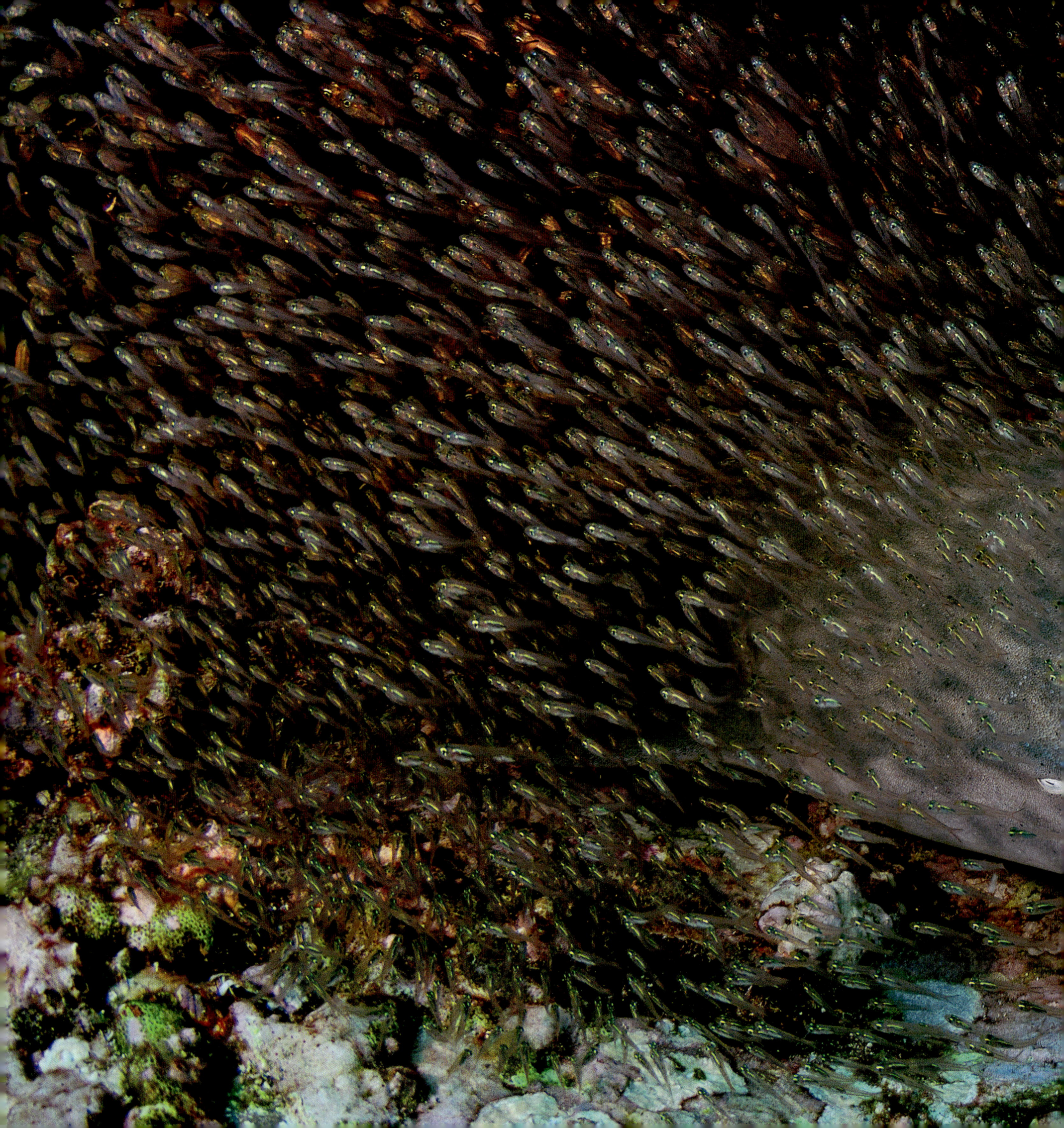

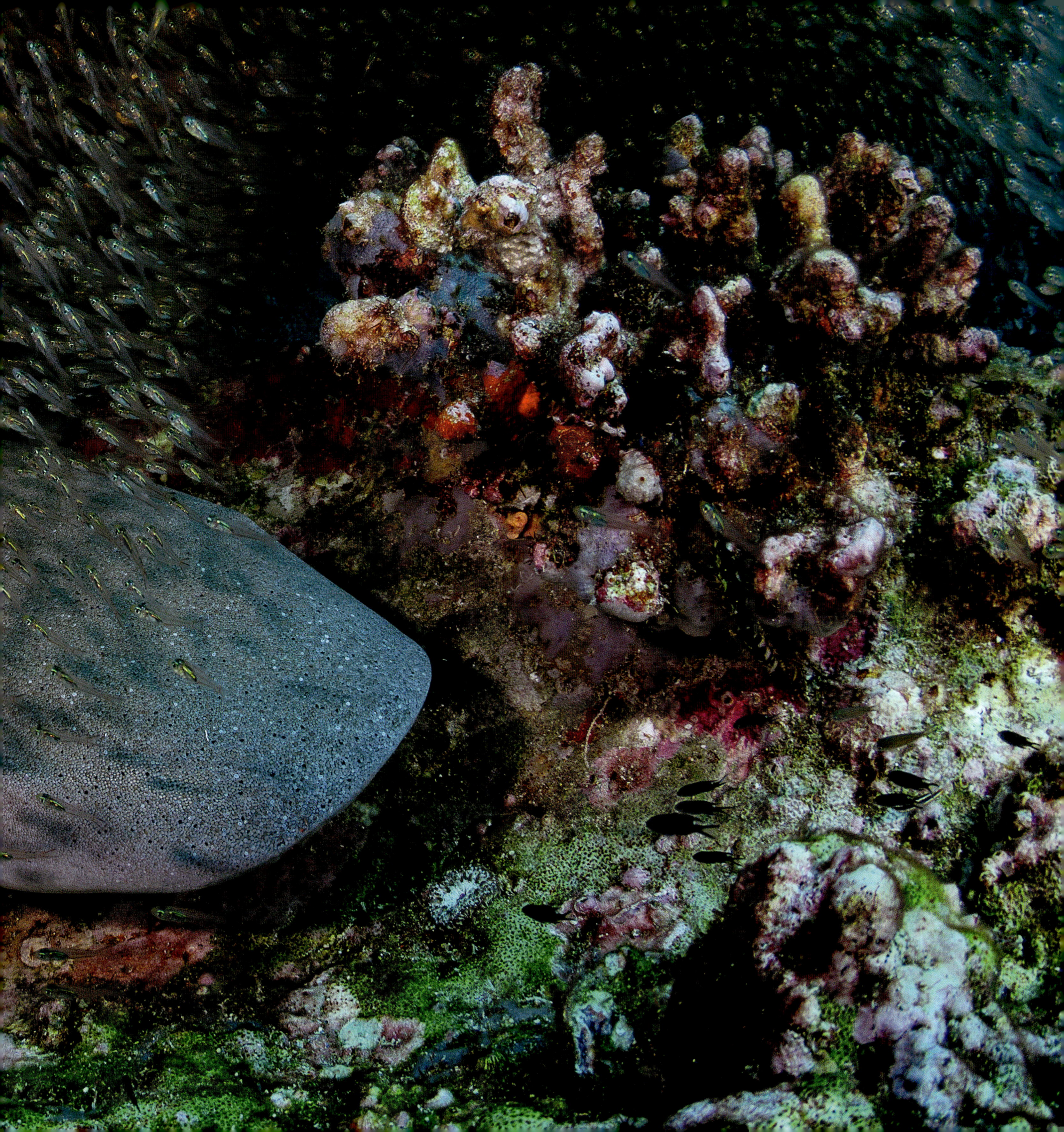

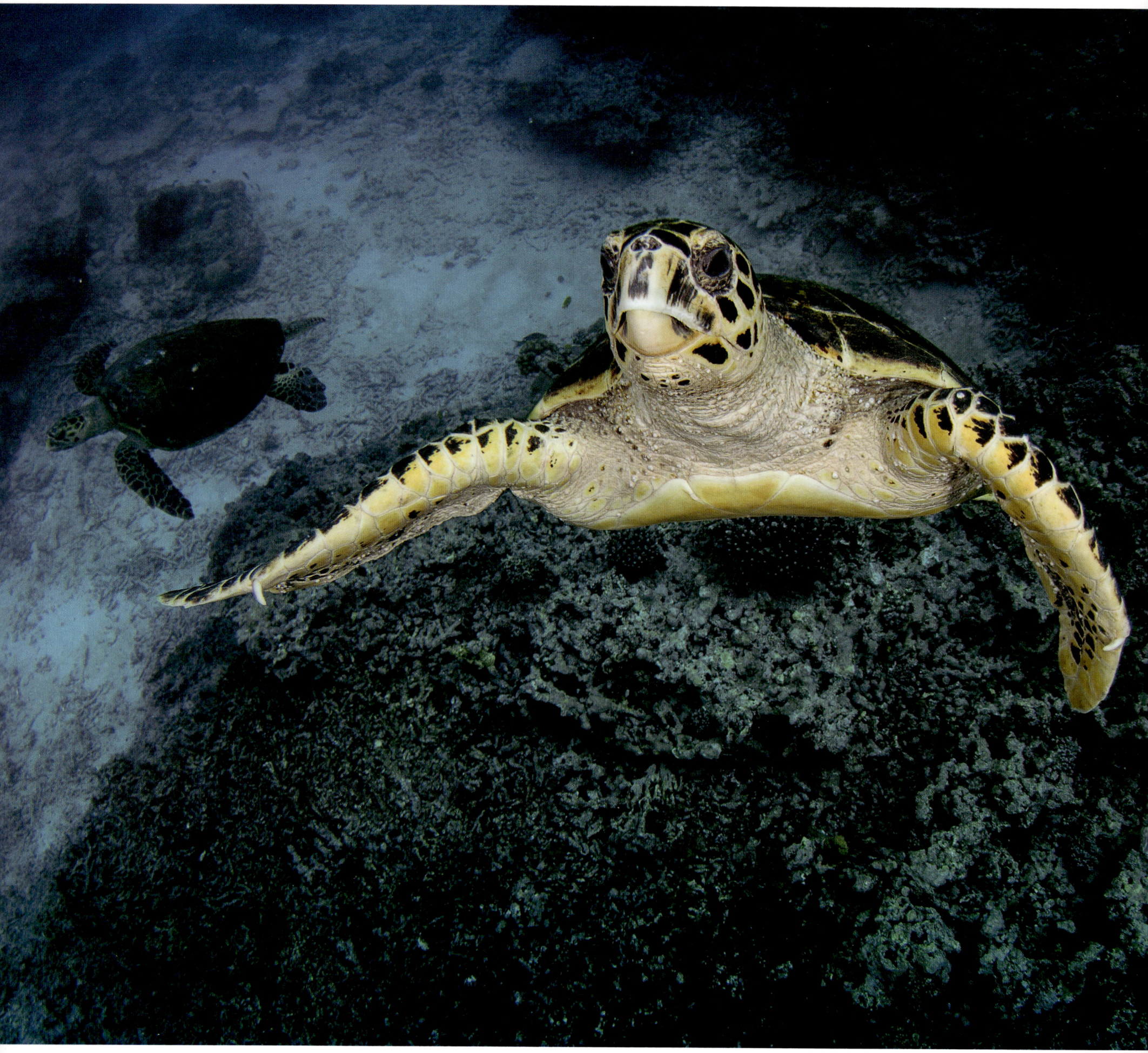

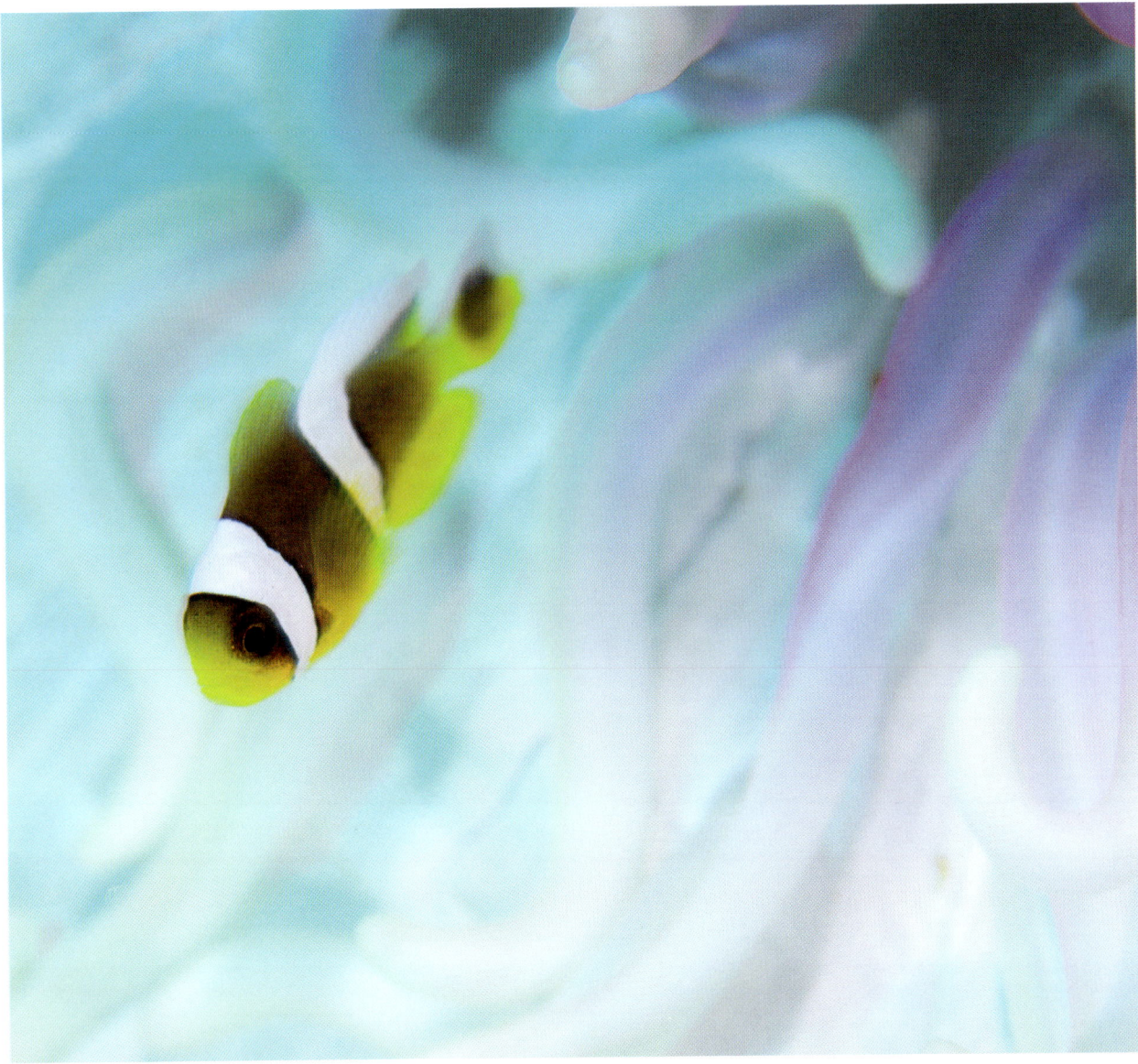

Above: An endemic Seychelles Anemonefish in its juvenile phase emerges from its delicate host anemone.

Left: Having had his amorous advances rebuffed by a female, a male Hawksbill Turtle rises to the surface to take a breath before trying to search for another more receptive female. Female turtles will often mate with several male turtles within a breeding season but they do not always make it easy for them.

Previous page: A Tawny Nurse Shark shelters in a cave packed with glassfish. These sharks are able to manually pump water over their gills enabling them to remain motionless for long periods of time.

Following page: Healthy branching *Acropora* corals still cover large areas of reef around Frégate Island unaffected by the bleaching event of 2016.

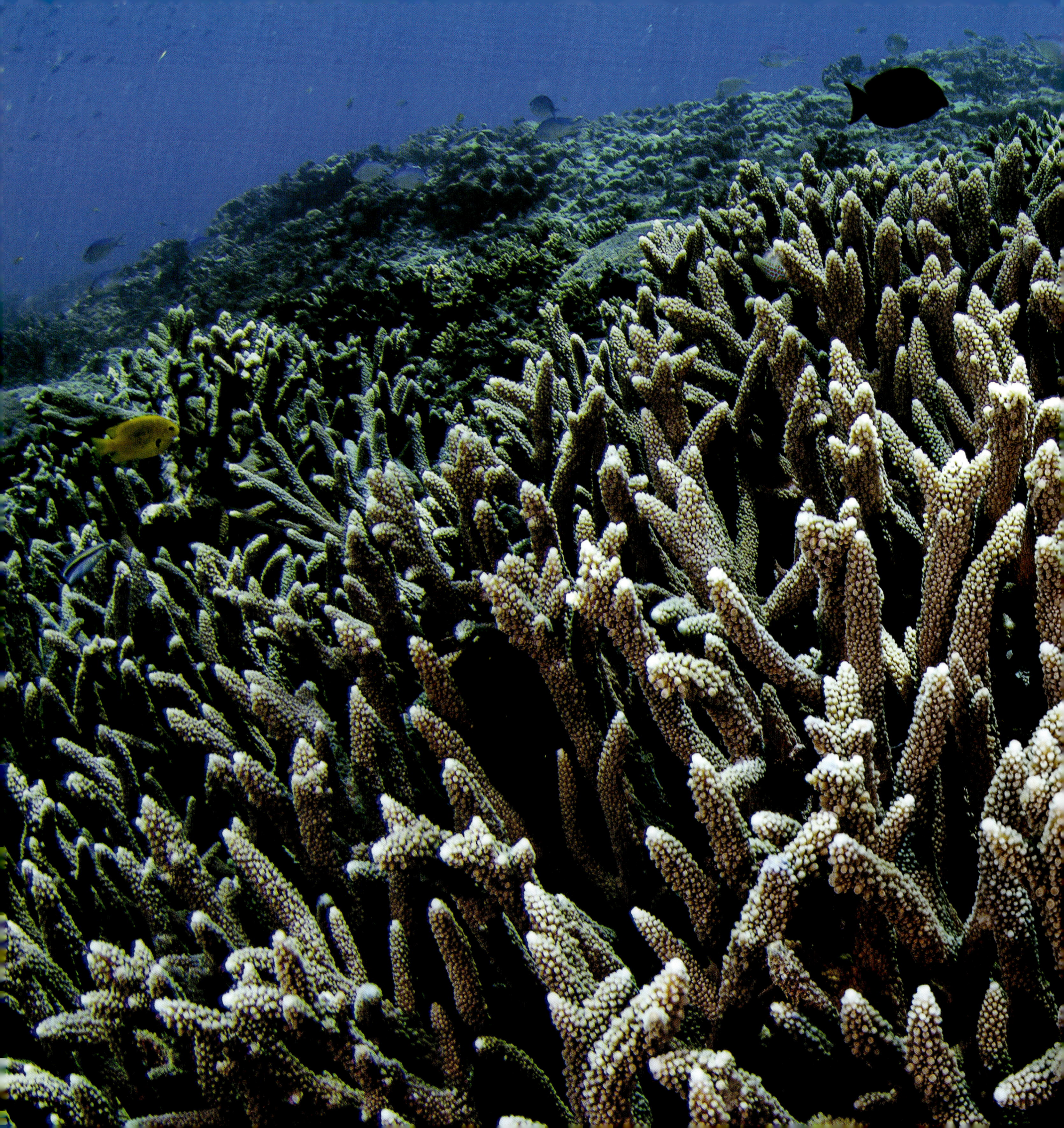

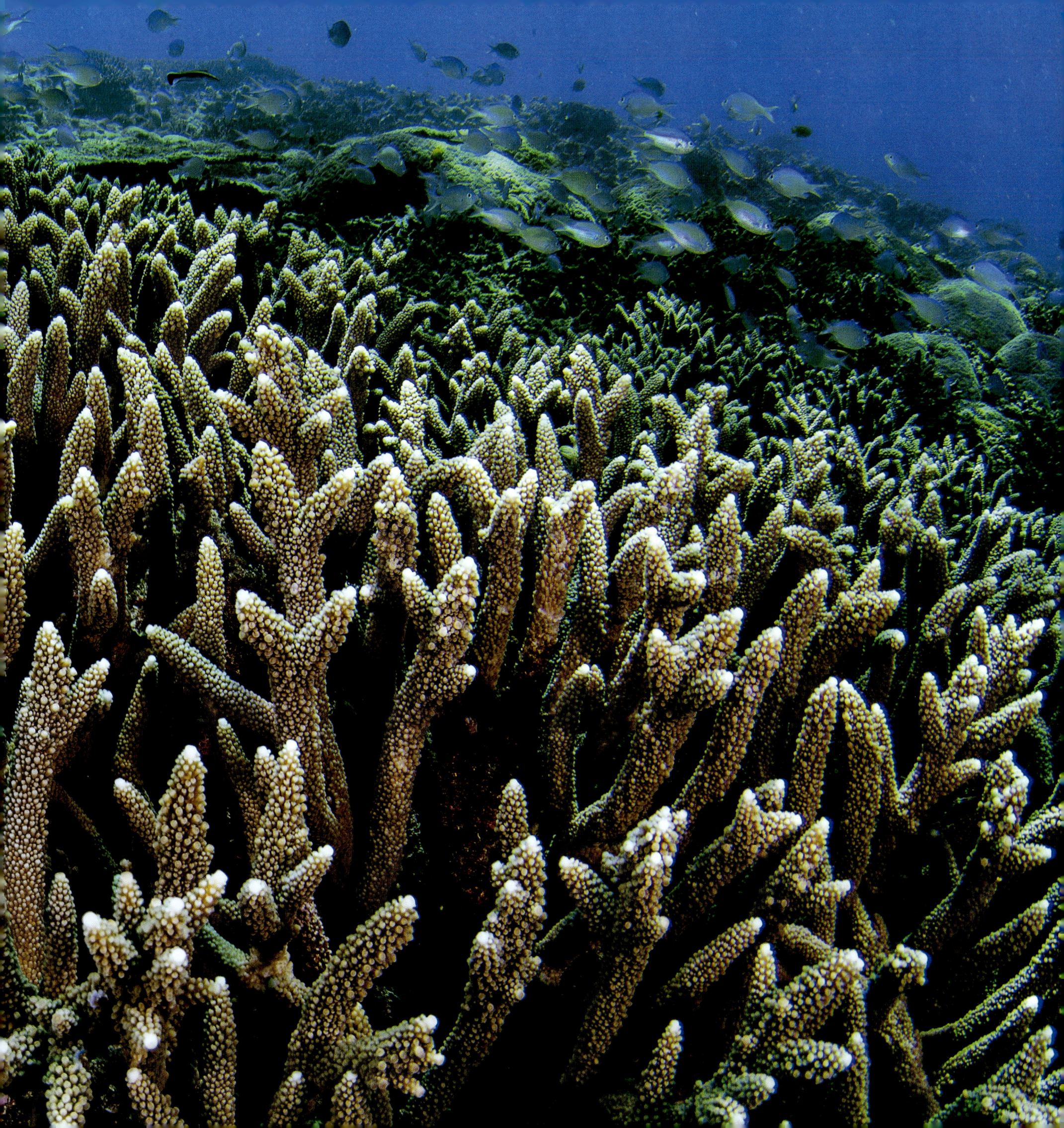

INTRODUCTION

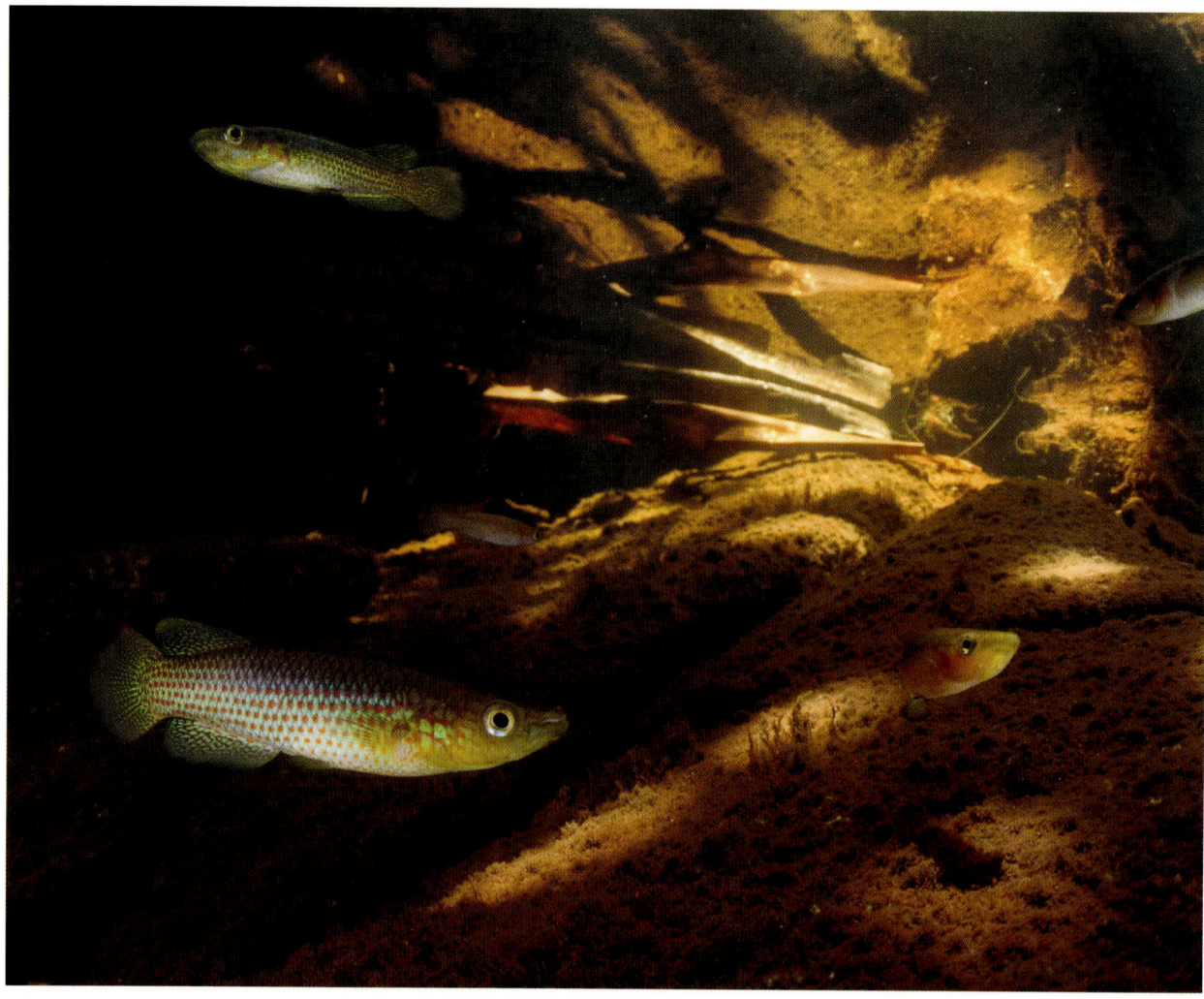

Above: Endemic Seychelles Killifish (*Pachypanchax playfair*) in a freshwater stream, high up in the Morne Seychellois National Park.

Right: A Snakehead Gudgeon is reflected in the mirror-like surface water at Anse du Riz. A halocline can be seen in the image where the upper layer of freshwater and the salt water below have failed to mix properly.

INTRODUCTION

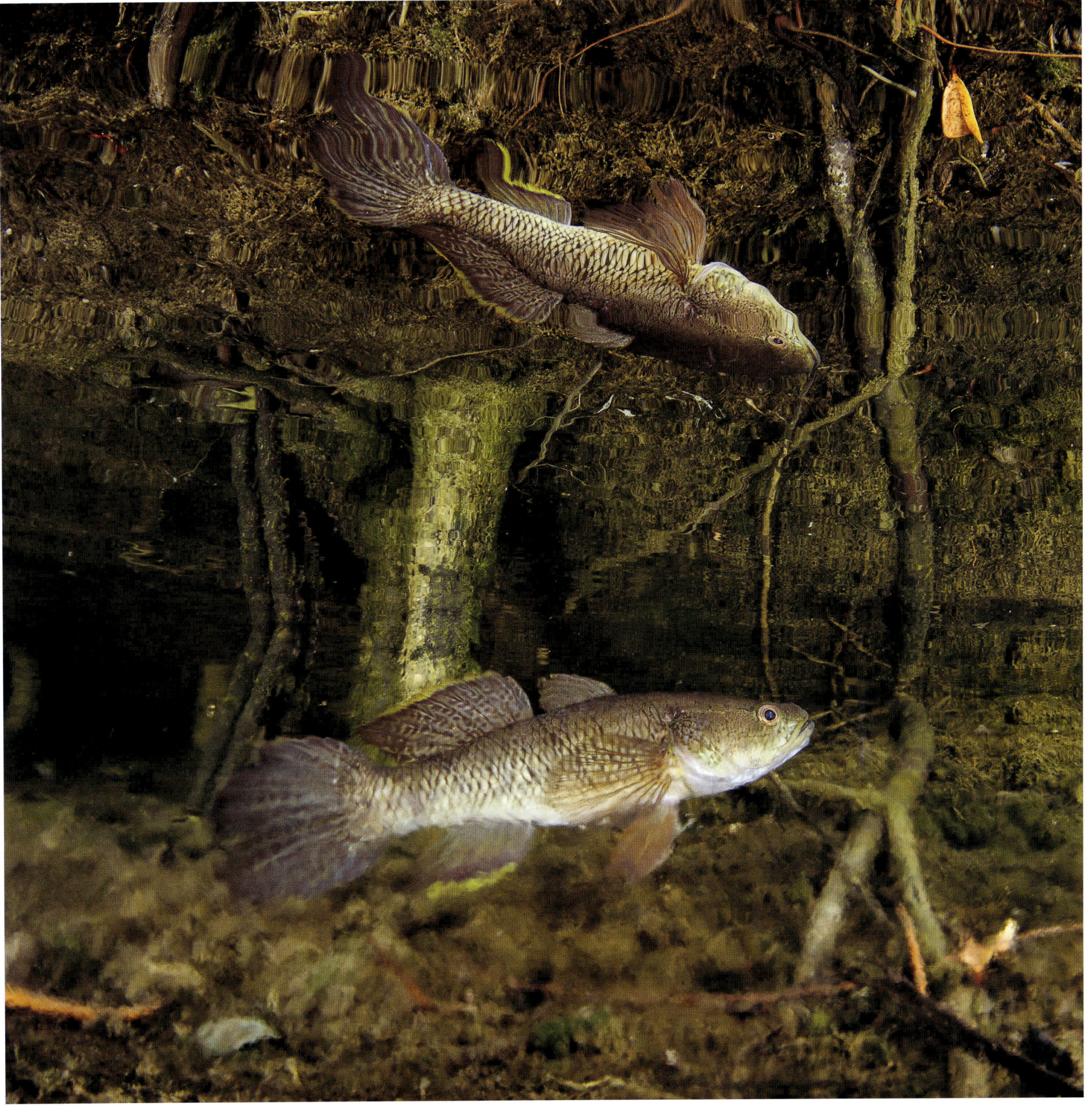

23

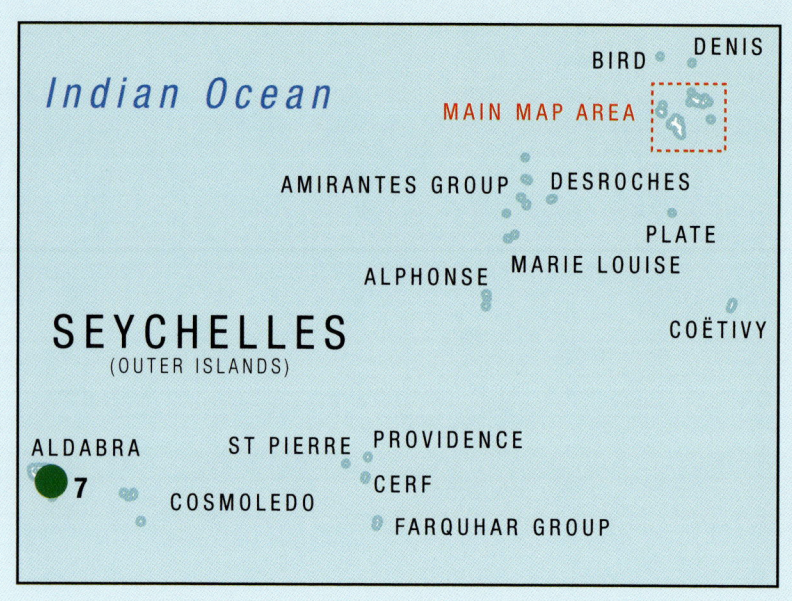

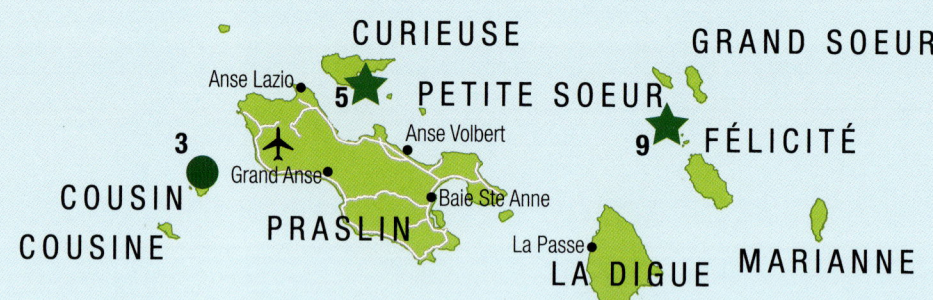
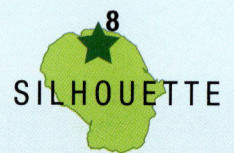
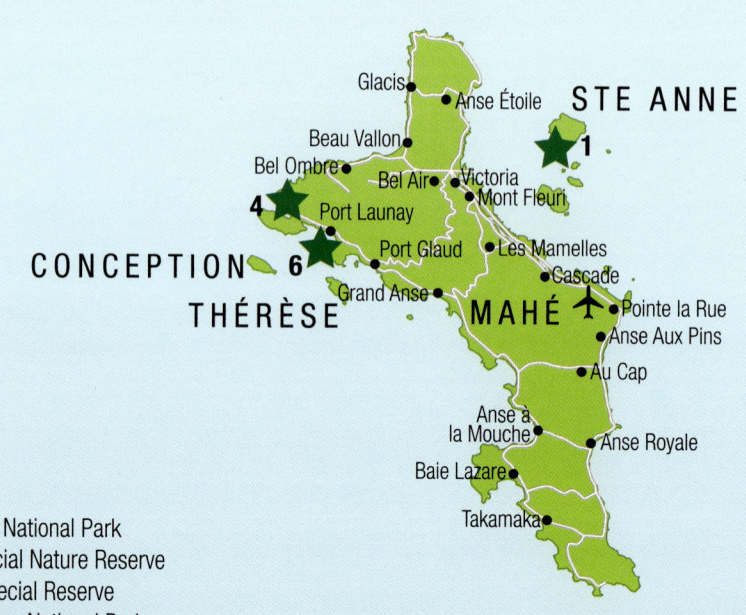

1. Ste Anne Marine National Park
2. Aride Island Special Nature Reserve
3. Cousin Island Special Reserve
4. Baie Ternay Marine National Park
5. Curieuse Marine National Park
6. Port Launay Marine National Park
7. Aldabra Special Reserve (UNESCO World Heritage Site)
8. Silhouette Marine National Park
9. Ile Cocos Marine National Park

INTRODUCTION

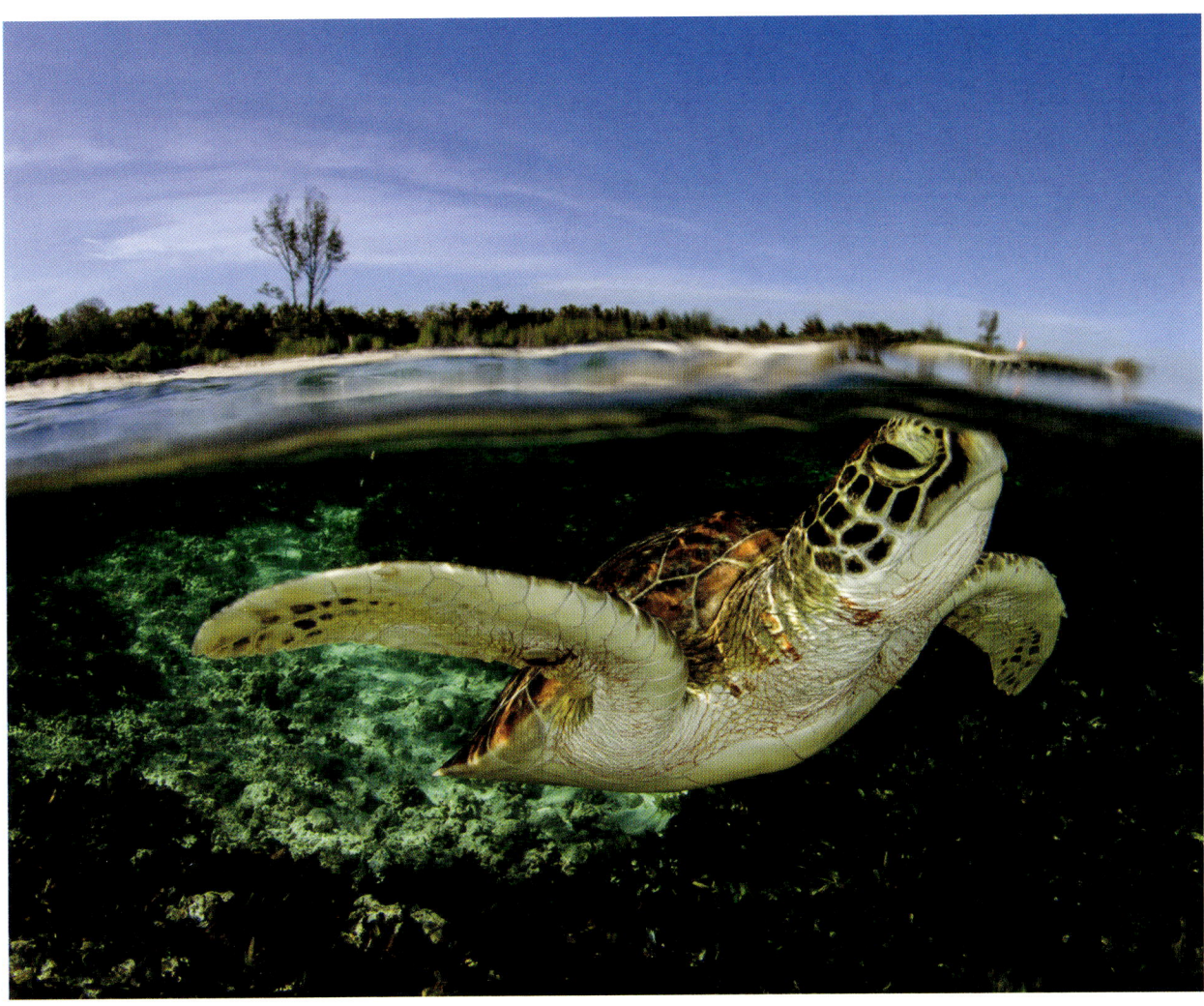

Above: Bird Island is an idyllic location for encountering young Green Turtles, which congregate in the shallow water surrounding the island.

Left: Map showing the Seychelles islands and their position within the country's EEZ. Marine Protected Areas are listed in order of designation.

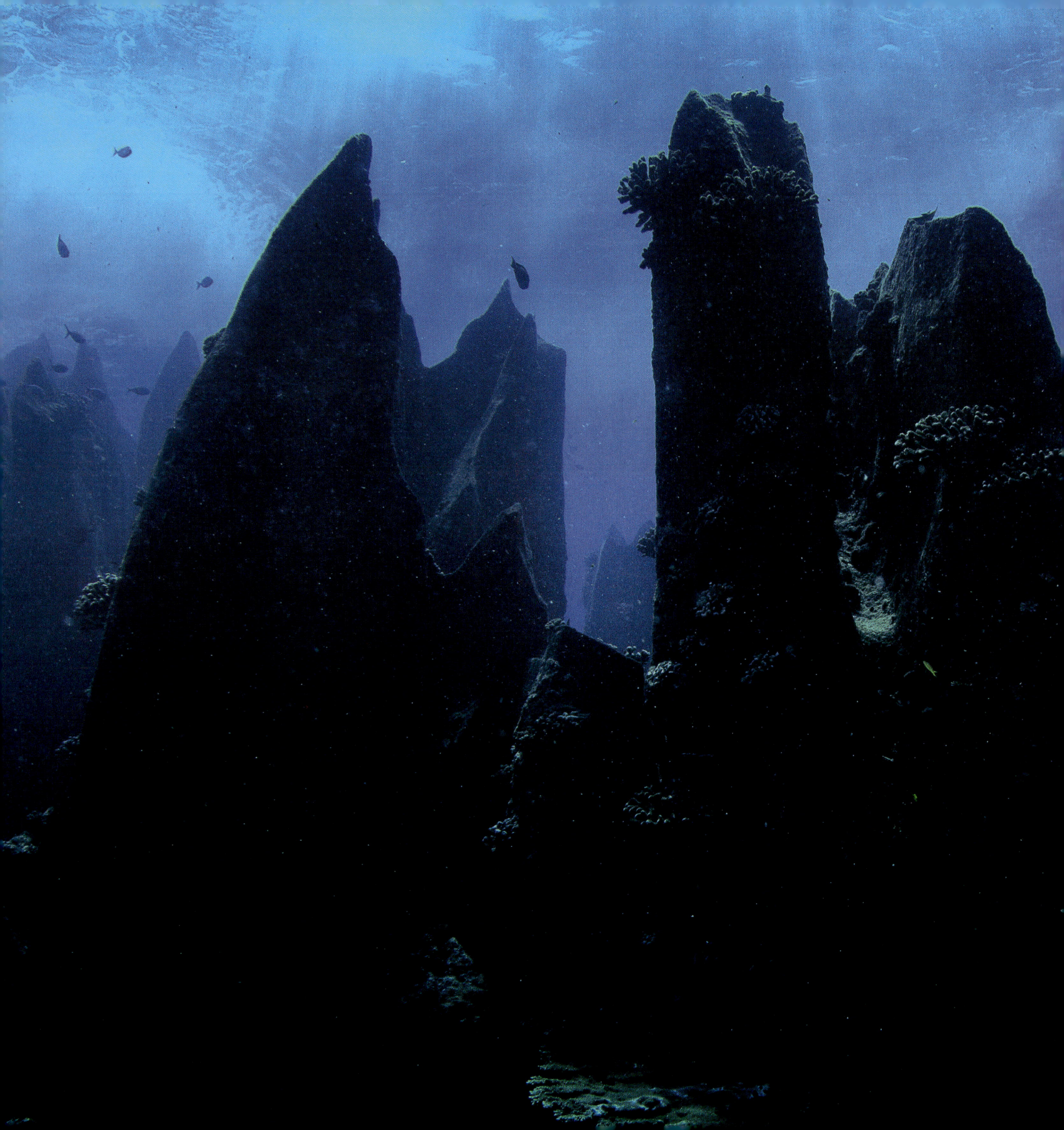

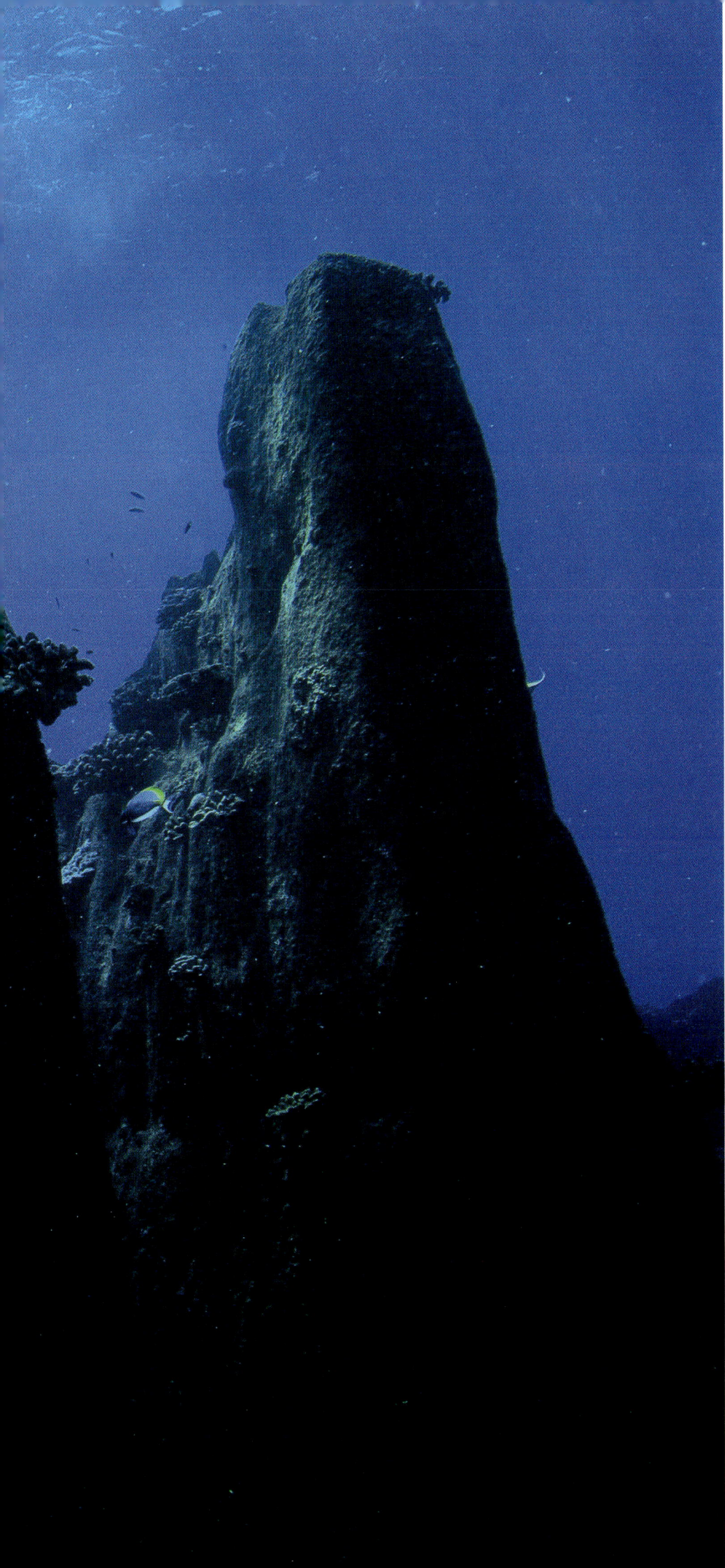

ECOSYSTEMS

The 115 islands that make up the Seychelles archipelago account for only 0.03 per cent of the nation's total area. They are spread out across the largest EEZ in the Western Indian Ocean, and the second largest in the whole of Africa. The coastal zones that surround these tiny islands, many of which are separated by vast expanses of water, support ecosystems that are home to an impressive variety of flora and fauna.

Left: The underwater topography of Marianne Island is impressive. Granite columns rise from the seabed to just below the surface. This particular area to the south of the island is well known for its aggregations of Grey Reef Sharks.

The granitic islands sit upon the Mahé Plateau and are separated by shallow water, which rarely exceeds depths of more than 70m (230ft). The larger islands are characterized by lofty peaks, their slopes covered in secondary forests that give way to inselbergs at their summits. These terrestrial, granitic ecosystems are geographically isolated and biologically distinct from those of their coralline cousins to the west. As is the case on all small islands, the land is inextricably linked to the sea, with biodiversity highly dependent on the interconnectivity of neighbouring habitats.

On Mahé, the largest of all Seychelles' islands, the peaks rise high above the valleys below, forcing warm air upwards in a process known as orographic lift. Humidity increases as rising warm air cools, and in the right conditions leads to precipitation. An island's topography plays an important role in defining its weather systems, and it is for this reason that Mahé and Silhouette, with their towering summits, receive significantly more rainfall than the other islands in the group. As the rain falls it collects in highland tributaries, which deliver water to crystalline waterfalls. These cascade into pools below, before swirling through narow valleys that lead to the sea.

These watercourses provide habitat for a variety of organisms, including freshwater species that are found nowhere else on Earth. The Golden Panchax (*Pachypanchax playfairii*) is the only endemic freshwater fish to be found in Seychelles, and is present on the larger islands of Mahé, Praslin and Silhouette. It grows to around 8cm (3in) in length, and the flamboyant male exhibits a markedly garish colouration when compared to that of the female, displaying vivid green and crimson spots. The gouzon, to give it its Creole name, is a plant spawner, and deposits its eggs on submerged vegetation in freshwater streams, where it feeds on insects and small crustacea.

Crabs also make their homes in the most unlikely of places and can often be seen in these highland streams. *Seychellum mahefregate* is one of three morphologically identical, yet genetically distinct species of freshwater crab found in the granitic islands of Seychelles. As the name suggests, this particular species is confined to the islands of Mahé and Frégate, where it burrows into the soft substrate along the banks of tributaries.

As the streams finally reach the coastline they pass beneath Takamaka and Bodanmyen trees. At certain times of the year the Bodanmyen, or Indian Almond as it is commonly known, bursts into a spectacle of colour. The trees' older leaves turn a fiery orange-red before falling to the ground, giving the coastal zone an autumnal appearance that juxtaposes vividly against the Coconut Palms, which are more traditionally associated with tropical latitudes. Many of the leaves gather in tributaries and drift into shallow coastal waters, where they decompose and provide vital nutrients for marine invertebrates and juvenile fishes.

The flora of the littoral zone is characterized by specialized vegetation, capable of being at least partially submerged for extended periods. Along the beach crest, plants such as Beach Morning Glory (*Ipomoea pes-caprae*) and Scaevola (*Scaevola sericea*) dominate the landscape, while remnant mangrove forests populate the margins at the border between land and sea.

Seven species of mangrove are found in Seychelles, all of which are highly adapted for the coastal environment. In the late 1700s, removal of mangrove forests to make way for coastal construction led to a reduction in cover in the inner islands. In recent years the trend has begun to reverse, with a proliferation of mangrove stands on the east coast of Mahé. Surprisingly, the increase in mangroves can be attributed to the creation of new coastal lagoons, produced as part of the on-going land-reclamation process around the island.

Mangroves are halotolerant and proficient in excluding salts when filtering saline water from the soil. They possess specialized aerial root systems known as pneumatophores, designed for the exchange of gas in anaerobic conditions. The Red Mangrove (*Rhizophora mucronata*) is a common mangrove species in the mature forest along the proximal zone, where its complex stilt roots create a microhabitat for a number of coastal species.

The ecological value of mangrove systems cannot be overstated. They play an important role in shoreline stabilization by trapping sediment, dissipating wave action and reducing coastal erosion. Many shorebirds utilize mangrove habitats as foraging grounds, and species such as the Grey Heron and endemic Seychelles Blue Pigeon nest within the trees' branches. Mangroves are nutrient providers for neighbouring marine ecosystems and contribute significantly to coastal fisheries by providing a nursery habitat for a variety of fish and crustacean species. The Mangrove Snapper (*Lutjanus argentimaculatus*) is a fish species with commercial importance throughout the Indo-Pacific region, whose juveniles inhabit mangrove areas until they reach maturity, at which point they move to deeper water.

For other species the life cycle is reversed. The Snakehead Gudgeon (*Giuris margaritacea*) is a thick-bodied fish with a flattened head. Adults are confined to freshwater and brackish mangrove habitats, where they hide among dense vegetation and mangrove roots. While the adults are exclusively found in fresh or brackish water, juveniles have a fully marine pelagic larval stage.

Right: The leaves of a Bodanmyen tree turn orange and gold during the dry south-east monsoon season before falling into coastal waters, where they provide food and vital nutrients for numerous marine organisms.

ECOSYSTEMS

Like mangroves, seagrasses are a vital part of the marine ecosystem. The only true marine angiosperms (flowering plants), they are unique among coastal vegetation. Confined to the photic zone due to their need to photosynthesize, seagrass beds are normally situated in shallow water, and in some locations are frequently exposed during low tides. Eight species of seagrass are found in Seychelles. Seagrass beds are located around all of the larger granitic islands, as well as many of the coralline islands throughout the archipelago, where they often support foraging aggregations of Green Turtles.

Seagrasses perform essential ecological functions in the coastal zone. They maintain water quality, stabilize the substrate, and provide food, habitat and nursery areas for marine vertebrate and invertebrate species. They are considered to be ecosystem engineers, actively altering their habitat.

The seagrass meadows of the Seychelles islands support diverse infaunal and epifaunal communities. The group of invertebrates known as echinoderms is particularly well represented, with several species of urchin and sea star regularly found. These include the Black-spined Sea Urchin (*Echinothrix diadema*), a shallow-water species often observed in large clusters on seagrass beds, and the Flower Urchin (*Toxopneustes pileolus*), which possesses blunt spines that if touched can deliver a painful sting. While the Black-spined Sea Urchin is rather obvious to the eye, the Flower Urchin covers itself in coral debris – an excellent camouflage technique that makes it extremely difficult to see. The precise reasons behind this covering behaviour remain poorly understood.

Another venomous fish type to be found here is the stonefish – a legendary fish whose venom, dispensed from venom sacs located at the base of the dorsal spines, can be fatal to humans. A master of disguise, the stonefish is an ambush predator and relies heavily on camouflage to capture fishes and crustaceans. It will often remain in rubble areas adjacent to seagrass beds, waiting for unsuspecting prey to pass by.

At certain times of the year, huge schools of baitfish such as the Goldspot Herring (*Herklotsichthys quadrimaculatus*) congregate above seagrass beds in shallow bays. There are numerous benefits to this schooling behaviour, including the sharing of information and safety in numbers. The ability of a single-species school to move as one can be attributed to sharp eyesight combined with a specialized layer of cells running along the length of the body. This 'lateral line' senses changes in water pressure, triggering impulses that instruct the fish on which direction to move. It is not solely schooling behaviour that provides the herring with protection, but by gathering among the

Left: A large number of sea urchin species utilize the seagrass beds around Seychelles, including this Black-spined Sea Urchin.

shallow seagrass beds the fishes avoid many of the larger predators that hunt on coral reefs.

Coral reefs are diverse, yet fragile ecosystems. They rely heavily on neighbouring seagrass beds and mangrove areas for nutrient cycling, water clarity and sediment trapping. Many coral reef fishes spend a portion of their life cycle within these adjoining habitats, highlighting the importance of the direct linkages between neighbouring ecosystems. Coral reefs are geological structures comprising the calcified remains of marine organisms. The living veneer, only a few millimetres thick, lies upon layers of dead and ancient reef. It is believed that while coral reefs only account for 0.2 per cent of the world's oceans, they suport one quarter of all marine species. This spectacular diversity is confined to a narrow band of habitat, where specific optimal conditions converge together and enable corals to grow.

The coral reefs of Seychelles are home to at least 50 genera of coral, which combine to form a complex three-dimensional habitat capable of supporting a dazzling array of marine biodiversity. These coral reefs can be subdivided into carbonate and granitic reefs. Carbonate reefs run parallel to the shores of many of Seychelles' islands, where they protect the coastline by reducing wave action. In the outer island group, coral reefs form atolls, which are created when a ring of coral grows around an island that subsequently sinks or erodes, often leaving a central lagoon.

The granite rocks for which Seychelles is famous also support diverse coral reef ecosystems below the surface, and these are known as granitic reefs. Huge boulders create intricate submarine structures, which provide the ideal surface for coral growth. Branching *Acropora* and *Pocillopora* corals jut out from the granite, surrounded by clouds of brightly coloured reef fishes. Encrusting corals and sponges give the surface of the granite boulders a multicoloured patchwork appearance. In places the granite has developed into impressive formations, the result of thousands of years of sculpting by the elements. Nowhere is this more apparent than on the south coast of Marianne Island, where cathedral-like spires rise from the seabed 25m (82ft) below.

Offshore granitic reefs are found throughout the Mahé Plateau. Some break the surface to form rocky outcrops or small islands, while others remain hidden from view. Like an oasis in the desert they are magnets for life, pockets of diversity in an otherwise barren landscape. The prolific marine life supported at these sites attracts pelagic fishes including trevally and tuna, which are regular visitors in search of a meal.

Right: Lush soft corals cover the granite boulders at L'ilot Island. L'ilot is often subjected to strong currents, providing the ideal growing conditions for these vibrant soft corals.

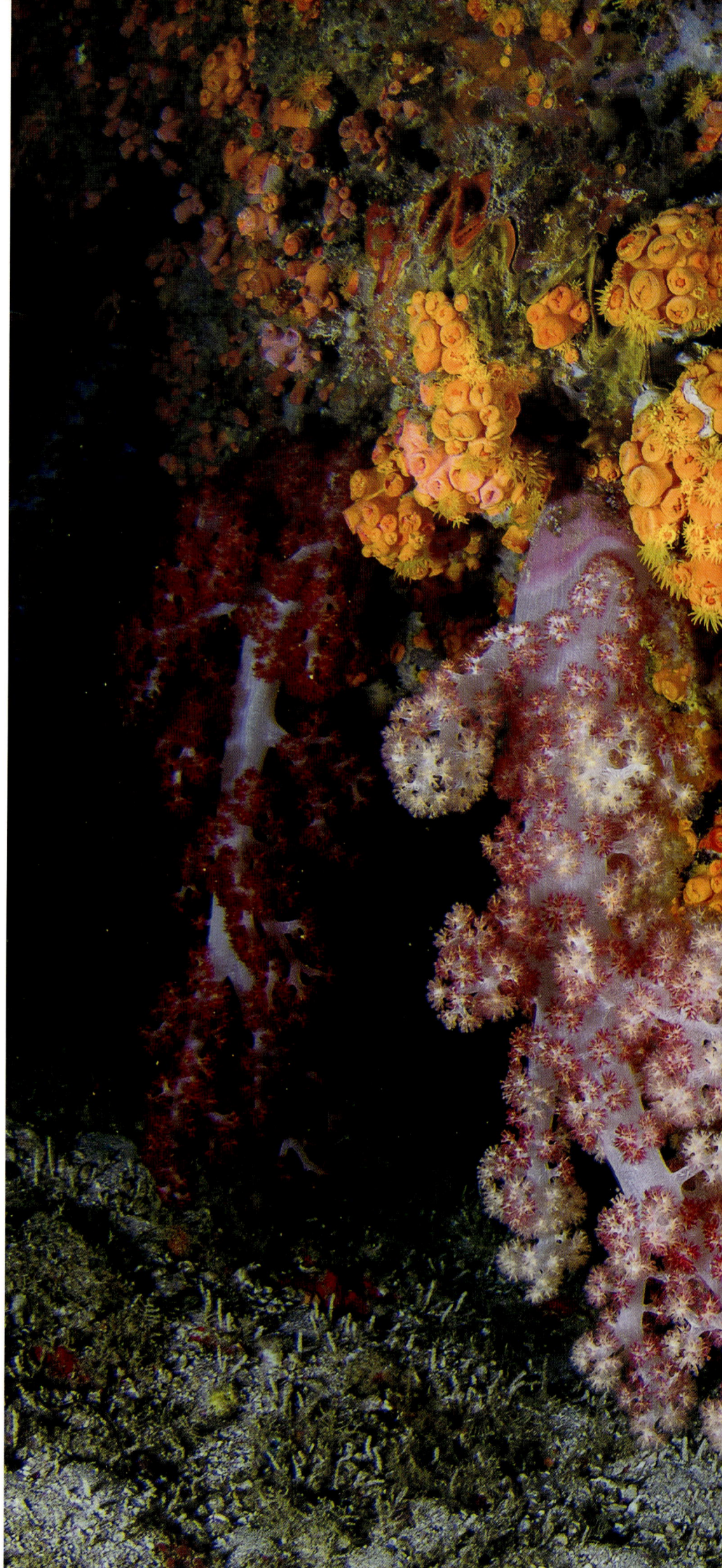

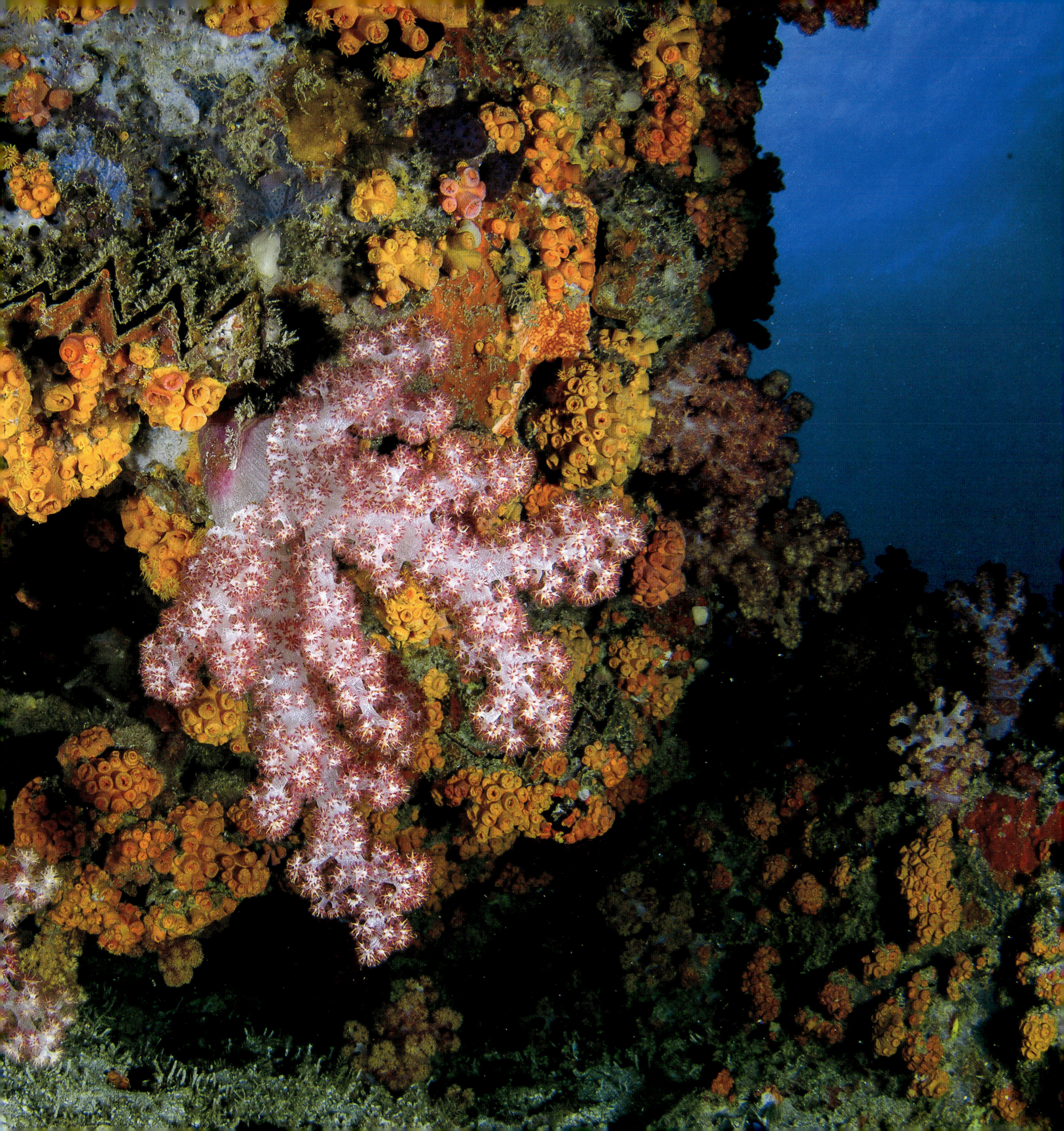

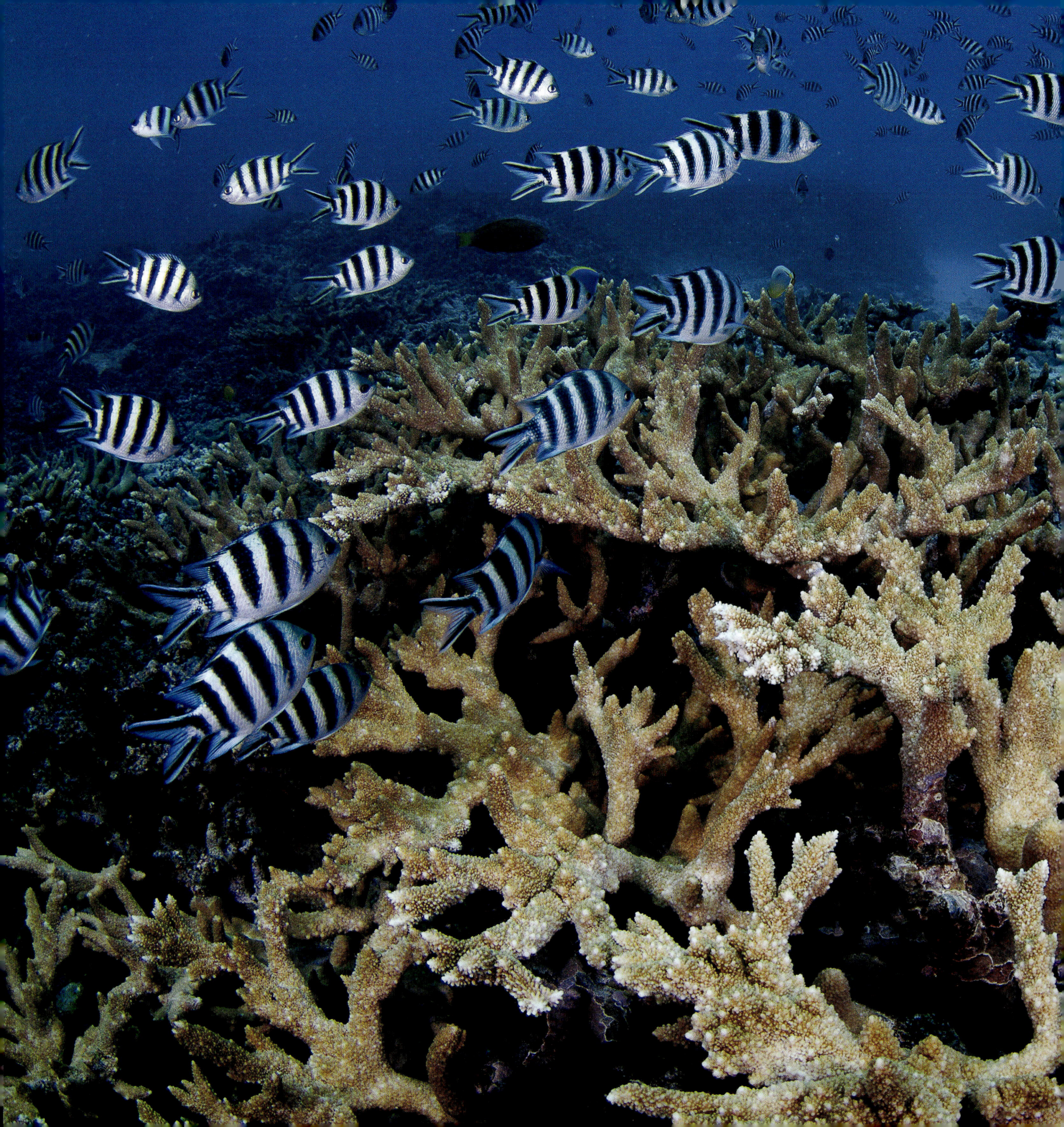

The hard, smooth surface of the granite boulders provides the perfect substrate for coral recruits to settle and grow. Corals are colonial marine invertebrates and are found in an endless variety of shapes and forms. Some species are slow growing and may take hundreds of years to reach just a few metres in diameter. These boulder corals, also known as massive corals, are robust and provide a foundation for other corals and countless marine organisms to flourish. By contrast, the delicate, branching *Acropora* corals are much faster growing and provide the reef with its complex three-dimensional structure.

The branching and massive corals, plus many other varieties, are the building blocks of the reef and are known as hermatypic. In addition to a suitable solid substrate for attachment, they generally require areas of minimal wave disturbance. The majority of species are zooxanthellate, locked into a symbiotic association with unicellular algae called zooxanthellae, and in order to develop require sunlight so that this algae can photosynthesize. They have a preferred temperature range of 25–29°C (77–84°F) and will not tolerate prolonged exposure to fresh water, higher air temperatures or changes in acidity.

Soft corals, by contrast to their hard coral relatives, are azooxanthellate species – they do not photosynthesize but instead feed by extending their polyps to extract plankton from the passing current and thus prefer the exposed locations of Seychelles granite reefs. The tiny islet of L'ilot, located 100m (328ft) from shore on the north-west coast of Mahé, is famous for its strong currents and soft corals in equal measure. The palm-topped granite boulders tumble beneath the surface to a depth of 22m (72ft). Vivid pink and lilac soft corals belonging to the family Nephtheidae cover the boulders, reaching out into the current with their tree-like branches. The corals compete for space with oysters, sponges and a multitude of other sessile (bottom-dwelling, immobile) marine invertebrates, resulting in an almost total cover of the granite surface.

Other corals to benefit from the reliable currents at L'ilot are sun corals, *Tubastrea* species, which carpet the undersides of the granite boulders and walls of caves and overhangs. Like soft corals, *Tubastrea* corals do not host zooxanthellae, and instead feed at night, using their tentacles to capture zooplankton from the water column.

Gorgonians, including sea fans and sea whips, are another azooxanthellate group of sessile organisms found throughout the tropics and subtropics, and often encountered on coral reefs. In the Indo-Pacific region, sea fans prefer water of at least 15m (50ft) depth, and for this reason they are most commonly located along the underwater walls and drop-offs of the outer islands. Around Alphonse and St François

Left: Scissortail Sergeants (*Abudefduf sexfasciatus*) school over extensive coral gardens around Frégate Island, feeding on plankton in the water column.

Atolls, huge orange sea fans, more than 2m (7ft) high, adorn reef walls facing the prevailing currents. They provide refuge for thousands of small fishes, which congregate around the coral colonies.

The intricate linkages between the assorted coral reef species form a complex food web consisting of different trophic levels. Autotrophic organisms, such as algae and bacteria, are able to produce their own food from light or chemical compounds. These primary producers support a diverse group of herbivorous organisms (called primary consumers), which range from tiny marine invertebrates, to reef fishes and marine turtles.

On coral reef ecosystems herbivory is essential to keeping algal growth in check, and a reduction in numbers of grazing reef fishes can lead to a phase shift towards an algal-dominated reef environment. Herbivorous rabbitfish make up a large part of the artisanal trap fishery within the Seychelles' inner islands. They are important primary consumers, and travel in large schools removing macroalgae from the reefs.

Secondary consumers are the reef's carnivores. They include a variety of molluscs, crustaceans and reef fishes. At the top of the food web sit the apex predators, including sharks and large-bodied groupers, which feed on larger fish species. A healthy reef ecosystem contains a high number of secondary consumers and apex predators, which perform an essential role in maintaining the reef equilibrium by predating on sick and dying animals.

Due to the high level of interconnectivity on coral reefs, a reduction in the number of species within one of the trophic levels can have severe implications for the entire food web. Today, this delicate balance is increasingly under threat from anthropogenic activities both locally and on a global scale. As the demand for seafood products rises to cater for population growth, burgeoning tourist numbers and a growing export market, there is an increasingly urgent need to adopt a precautionary approach to the harvesting of marine resources. Furthermore, coastal development for tourism infrastructure is leading to a reduction in the health of marine ecosystems by disrupting their ability to function properly. The physical damage of seagrass beds and mangrove forests destroys fish nursery areas and leads to increased sedimentation on coral reefs. The interdependency within coastal ecosystems is crucial to their individual success, and if one critical element is altered or destroyed, the others will undoubtedly suffer.

Right: A collection of mushroom corals off Cerf Island. Mushroom corals belong to the genus *Fungia*, and, unlike most corals, the adults are free-living rather than being attached to the substrate.

Following page: A school of fusiliers streams across a submerged granitic reef known as Brissare Rocks. The coral reef forms part of a submerged chain of granitic reefs that stretches between Mahé and Praslin Islands.

ECOSYSTEMS

Above: A Pinkeye Goby (*Bryaninops natans*) rests on the axial corallite of an *Acropora* coral. Schools of these tiny gobies hover above *Acropora* corals, pausing only occasionally to rest.

Right: A solitary trevally makes use of the crevices of brightly coloured coral- and sponge-encrusted granite boulders to hunt its prey.

Following page: Vast schools of snappers encircle huge granite boulders at a dive site called Shark Bank.

ECOSYSTEMS

ECOSYSTEMS

Above: A male Seychelles Killifish inspects its flamboyant colours in the dome port.

Above: Beach Morning Glory is an attractive coastal vine commonly encountered along Seychelles shorelines, where it is able to withstand the harsh and saline conditions.

Following page: A male Seychelles Killifish and some of his harem of females.

ECOSYSTEMS

Above: The intricate structure of many corals can only be seen when up-close, as shown here in this brain coral *Leptoria* sp.

Right: The *Galaxea* sp. coral has an exquisite colour and structure.

Following page: Thousands of brightly coloured anthias school around the numerous sea fans that cover the reef walls at Alphonse Island.

ECOSYSTEMS

ECOSYSTEMS

Above: An inquisitive Picasso Triggerfish (*Rhinecanthus aculeatus*) examines the camera dome port, whilst exploring the seagrass beds at Bird Island.

Left: A bustling granite reef scene from Frégate Island.

Following page: Huge schools of yellow snapper engulf vast areas of a dive site called Dragon's Teeth.

ECOSYSTEMS

ECOSYSTEMS

Above: The flower urchin *Toxopneustes pileolus* is common in shallow water environments such as seagrass beds, where it covers itself with sand and rubble, making it hard to detect. Care should be taken if walking in areas inhabited by the urchin, as it is venomous and can deliver an extremely painful sting.

Right: A stonefish lies in wait for its prey. Stonefish are extremely venomous and possess individual venom sacs at the base of each of their spines. If stepped on, the spines can inject venom into the foot, causing excruciating pain.

Following page: A healthy coral reef at Alphonse Island. The reefs around the Alphonse and St François Atolls were not as severely impacted by the 2016 coral bleaching event as those around the granitic islands.

ECOSYSTEMS

ECOSYSTEMS

Above: Small baitfish shelter beneath the twisted and submerged roots of the mangroves at Anse Soulliac, Mahé.

Left: The complex network of mangrove roots creates barriers to keep out would-be predators and provide safe havens for juvenile fish.

Following page: Sea fans prefer areas subjected to strong currents, such as the outer walls of Alphonse Atoll where they grow to over 3m (10ft) in height.

ECOSYSTEMS

Above: Silver baitfish evade predators by schooling tightly together in the shallow seagrass beds of the Baie Ternay Marine National Park.

Right: A school of young trevally on the move in the evening light. Aggregations of juvenile and sub-adult fish tend to prefer the relative safety of shallow water close to the shore.

Following page: A huge school of fusiliers streams past a coral outcrop on St François Atoll.

ECOSYSTEMS

ECOSYSTEMS

Above: A single healthy colony of *Acropora* thrives in the shallow, sunlit back-reef of the Baie Ternay Marine National Park.

Left: A Green Turtle grazes upon the lush seagrass beds that surround Bird Island. The turtles arrive on a rising tide and feed continuously for several hours. There is an intricate and complex relationship between sea turtles and seagrass that is still not fully understood.

Following page: A school of Bluelined Snapper (*Lutjanus kasmira*) congregates beneath an overhang on a reef at Alphonse Island.

TURTLES

Marine turtles are an ancient group of animals that have roamed our planet's oceans for more than 150 million years. Six of the seven extant species belong to the family Cheloniidae, while the mighty Leatherback Sea Turtle (*Dermochelys coriacea*) is the solitary representative of the family Dermochelyidae. Historically, these iconic creatures have been bestowed mythological and spiritual importance by cultures across the globe. Seychelles is no exception, and marine turtles have played a significant part in the local culture since people first visited the islands.

Left: A Hawksbill Turtle at Frégate Island stares at its reflection in the dome port of the camera.

Traditionally, turtles were exploited as an important natural resource, both for local consumption of their meat and through the export of their shells. More recently their value as a source of tourism revenue has been recognized. Today many of the islands have well-established turtle monitoring programmes that include education and outreach initiatives, aimed at sensitizing the public to the importance of sea turtle conservation.

Five species of sea turtle are found in Seychelles waters, yet only two haul onto the archipelago's beaches to lay their eggs. The Green Turtle (*Chelonia mydas*) is currently listed on the IUCN Red List of Threatened Species as Endangered, and has a range that extends throughout the world's tropical and subtropical oceans. In Seychelles, it is most numerous among the outer islands, and in particular at the UNESCO World Heritage site of Aldabra Atoll, which boasts the Western Indian Ocean's largest nesting Green Turtle population. The species is known locally as *torti-d-mer* and is favoured for its meat. Its name derives not from the colouration of its shell, but from the colour of its fat and cartilage.

Small numbers of Green Turtles nest in the inner islands, though their numbers have been depleted from years of over-exploitation. Today, the neighbouring coral islands of Bird and Denis, the only coralline islands in the inner island group, are home to aggregations of young Green Turtles, which visit the shallow near-shore waters to feed on the extensive seagrass beds. Green Turtles are known to migrate long distances between feeding grounds and nesting beaches, with juveniles showing a preference for shallow coastal waters.

Around Bird Island, the Green Turtles spend much of their time grazing on seagrass. A large proportion of their diet comprises *Thalassia hemprichii*, although several other species of seagrass are also eaten. The turtles access these lush foraging grounds on a rising tide, passing over the reef crest and settling onto the seagrass meadows that run adjacent to the shore. Over the next few hours they feed continuously, using their specially designed jaws to cut through the seagrass blades. Like all reptiles, turtles need to breathe air, and while they can remain underwater for several hours when at rest, feeding Green Turtles will surface every 15 minutes or so to grab a gulp of air, before returning to the task at hand. As the tides begin to recede, the turtles retreat to deeper water to avoid becoming stranded.

The relationship between Green Turtles and their foraging grounds is an interesting one. While seagrass provides the animals with their necessary nutritional requirements, the process of grazing increases the productivity and nutrient content of seagrass blades. In addition, a high density of Green Turtles in an area may exert top-down control, altering the local seagrass composition and preventing single-species dominance.

Unlike their Green Turtle cousins, Hawksbill Turtles (*Eretmochelys imbricata*) are associated with coral reefs, where they feed on a variety of organisms. Their diet predominantly consists of sponges (which are the source of the toxins that can render their meat poisonous for human consumption), but they also eat algae, anemones and jellyfish. There are few natural predators remaining in the inner islands, as numbers of large-bodied groupers and sharks have been heavily depleted, but at night Hawksbill Turtles still avoid potential danger by wedging themselves under ledges and coral outcrops.

Seychelles is home to the largest nesting Hawksbill Turtle population in the region, and one of the five largest remaining national nesting populations in the world. The Hawksbill Turtle typically grows to less than 1m (about 3ft) in carapace length, and the species is characterized by its beak-like mouth and the presence of two claws on each limb. The overlapping scutes on the animal's carapace are also unique to the species.

In Seychelles, the Hawksbill Turtle nesting season runs from September to February. During this time adult turtles congregate in shallow waters near nesting beaches, where they can be seen in good numbers. Known locally as *kare*, the Hawksbill Turtle prefers to lay its eggs during the day. This behaviour does not occur throughout the species' range, but is limited to locations in the Western Indian Ocean.

Following mating, the female turtles drag themselves ashore and dig a nest chamber, into which they lay an average of about 165 eggs. Not every emergence results in successful egg laying, and a female turtle may make several attempts before finally settling on a suitable location to dig her nest and deposit her clutch. Once the eggs are in the chamber, she begins the arduous process of covering them, before finally turning and heading back to the sea. Within a nesting season, a female can lay up to six egg clutches (although clutches usually average three or four). A female may mate with several males early in the nesting season and by storing their sperm, she enhances the genetic diversity of her offspring. Unlike females, the males rarely come ashore and spend most of their life in the ocean.

Right: A Green Turtle rises to the surface for a breath during a tropical downpour.

TURTLES

About two months after they are laid, the eggs begin to hatch and the tiny newborn turtles make their way to the surface of the sand to begin their perilous journey to the sea. Along the way to the water's edge they must avoid ghost crabs, shorebirds and a host of other threats. Once in the sea, they become the target of predatory fishes and reef sharks, and it is of little surprise that few turtle hatchlings survive the 30–40 years it takes for them to reach adulthood. This is when they return to the vicinity of the beaches where they were born, enabling the whole process to begin again.

The Green Turtle has a long history of persecution in the Seychelles islands, where it has been targeted for its meat since the beginning of human settlement in the late 1700s. During the twentieth century, before 1968, thousands of Green Turtles were exploited annually for their *calipee*, a thick layer of cartilage found inside the plastron, which was dried and exported to Europe as a key ingredient of turtle soup. This export market was responsible for a precipitous decline in the Green Turtle nesting populations of Seychelles during the 1900s, which was then exacerbated by continued local hunting of the remaining turtles for domestic meat consumption.

Historically Hawksbill Turtles have been targeted as part of the international trade in tortoiseshell, though increasingly poaching is now for the meat. Many Seychellois will not eat Hawksbill Turtle meat, however, as it can be poisonous to humans. Unfortunately, once a turtle is butchered, and its meat salted and dried, it is difficult to distinguish Hawksbill Turtle meat from that of the Green Turtle.

In response to declining sea turtle numbers, the Seychelles government passed a law in 1994 making it illegal to eat, possess, sell or kill marine turtles. Despite strict fines of up to SCR 500,000, alongside a maximum two years in prison and the confiscation of one's vessel, poaching of Hawksbill and Green Turtles still persists to this day. Some people continue to view the eating of turtle as part of their cultural heritage and remain reluctant to abandon this traditional custom. For many others, however, attitudes are changing. Environmental education and awareness programmes in the country are having a positive effect in altering behaviour, and marine turtles are increasingly viewed as an important natural asset and a source of tourist income that should be cherished and protected.

Globally, the Hawksbill Turtle is classified on the IUCN Red List of Threatened Species as Critically Endangered, with more than an 80 per cent decline in global population numbers in the past three turtle generations (over approximately 100 years). To provide some historical context, in Seychelles there was a particularly significant decline in Hawksbill Turtle numbers between the 1960s, when exploitation was at its highest level, and 1990, when its legal global trade ceased. Today, on islands densely populated by people, the species is restricted to nesting in small numbers on remote beaches. On some of the smaller, less developed islands, where the turtles have been protected during the past two to four decades, there are some exciting success stories in their protection. The Special Reserves of Cousin and Aride Islands are cases in point, with both having experienced an approximately eight-fold increase in nesting Hawksbill Turtles. Similar increases have been documented for Green Turtles at Aldabra Atoll. All these islands have been protected since the 1970s, and they provide a striking example of how populations can rebound in the absence of poaching and anthropogenic disturbances.

Elsewhere in Seychelles, wherever the turtles have been afforded serious protection at their nesting beaches, their populations have also responded favourably. Today, there are nearly 20 well-established sea turtle conservation and monitoring programmes on many of the inner and outer islands of Seychelles, implemented through the combined efforts of local NGOs, private island owners and government departments.

The presence of healthy marine turtle populations is of local importance both ecologically and fiscally. They are regularly observed at diving and snorkelling sites, and this coupled with the Hawksbill Turtles' preference for nesting during daylight hours, makes Seychelles one of the world's premier destinations for accessible wild turtle encounters, both on land and in the water. Revenue generated from ecotourism, including wildlife tours and conservation-based volunteer programmes, has the potential to form an increasingly vital part of the country's future tourism strategy. Globally, the survival of these amazing species may be fraught with challenges, but in Seychelles sea turtles remain an integral part of the archipelago's marine ecosystem.

Left: In Seychelles, Hawksbill Turtles nest during daylight hours, making them more susceptible to poaching. Within the granitic island group, it is the protected and less-populated islands, and the more inaccessible beaches, which continue to support higher numbers of these nesting turtles.

TURTLES

Above: Hawksbill Turtle hatchlings bravely make their way down the beach to the ocean on Bird Island. At this stage of their life the hatchlings are extremely vulnerable, and have to avoid many predators before they even reach the ocean. The journey does not stop there and these hatchlings will ride the ocean currents for many years before returning to these reefs to feed and eventually mate. The chances of this individual making it to adulthood are extremely slim.

Above: A Hawksbill Turtle hatchling sets out on its epic journey.

Above: A young Green Turtle takes a break from feeding on seagrass to surface for a gulp of air. The shallow-water seagrass beds that surround Bird Island and Denis Island provide the ideal foraging grounds for the turtles.

Opposite: The shallow seagrass beds around Bird Island are home to a healthy population of Green Turtles.

Above: Unlike the outer islands, and in particular Aldabra, which has the largest Green Turtle nesting population in the Western Indian Ocean, Green Turtles have never been particularly common within the inner islands. Today the best place to see the species within this area is around the coralline islands of Bird and Denis.

Right: A Green Turtle feasts on seagrass in the shallows of Bird Island.

TURTLES

Above: A large male Hawksbill Turtle looking for females off of Frégate Island.

Left: Seychelles is home to one of the five largest remaining Hawksbill Turtle nesting populations in the world.

Above: Despite their hard shell, Hawksbill Turtles are still vulnerable to predation by large sharks hunting at night. For protection they utilize the structural complexity of the reef and often wedge themselves under ledges or coral bommies where would-be predators cannot reach them.

Right: Although the species is Critically Endangered, juvenile Hawksbill Turtles are a relatively common sight on the coral reefs of the inner islands. During the mating season, however, large males begin to appear close to shore searching for females to mate with. Male turtles rarely come ashore and spend most of their lives in deeper waters, only coming to shallower waters during their breeding season.

Following pages: A large male Hawksbill Turtle feeding on sponges in the Baie Ternay Marine National Park.

TURTLES

Above: Hawksbill Turtles are associated with coral reefs, where they feed on a variety of marine invertebrates including molluscs, crustaceans and jellyfish. They are particularly fond of sponges and will often remove large pieces of coral to gain access to their preferred food.

Opposite: A Green Turtle dives for the seabed, having just surfaced for air. When feeding, Green Turtles will surface every 15 minutes or so to breathe, although a resting turtle is capable of holding its breath for a number of hours.

FISHES

There are more than 30,000 species of fish on the planet, accounting for 60 per cent of all vertebrates, and over half of all fish species are found in the oceans. To date, almost 900 fish species have been recorded in Seychelles waters, highlighting the importance of the nation's geographical location as a marine biodiversity hotspot.

Left: The largest fish on the planet, the Whale Whark, is a seasonal visitor to the waters surrounding the inner islands of Seychelles, where it comes to feed on blooms of plankton.

It is well known that due to a long period of isolation and their unique geological history, the islands of Seychelles are home to a number of endemic animals that are found only on these small land masses in the middle of the Indian Ocean. By contrast, the ocean is a geographically connected, open system. Because of this, less than a dozen endemic fish species inhabit the vast expanse of Seychelles' territorial waters. The Seychelles Anemonefish (*Amphiprion fuscocaudatus*) is one of the most common marine endemics, and undoubtedly the most charismatic. Like other anemonefish species, it has a symbiotic relationship with its host anemone, with both animals benefiting from their mutual association. The stinging tentacles of the anemone provide the fish with protection from predators and a safe nesting site for the eggs of the fish. In addition, the fish scavenges the odd dead anemone tentacle, alongside scraps of food left by the anemone. In return for these benefits, the fish defends the anemone from predators and keeps it free from parasites.

Symbiotic relationships abound in the fish-eat-fish world of the coral reef. Whip corals protrude from coral gardens, granitic rocks and the flanks of shipwrecks, and when inspected closely small, semi-translucent gobies can be found living on their surfaces. These Whip Coral Gobies (*Bryaninops yongei*) utilize the corals for protection, their small size enabling them to blend in effectively, thus avoiding predators. The gobies also remove polyps from a small area of a coral and lay their eggs directly onto the exposed surface. In return for this minor inconvenience, the gobies eliminate toxic algae from the surface of the coral, as well as cleaning off any build-up of mucus.

Away from the security of the reef and out into the open ocean, pilot fishes such as juvenile Golden Trevally (*Gnathanodon speciosus*) accompany larger animals as a means of seeking refuge from predators. They are often seen swimming immediately in front of one of the seasonal visitors to the inner islands, the Whale Shark (*Rhincodon typus*).

From June to November the south-east trade winds blow hard across the Indian Ocean. The winds create upwellings that bring cold, nutrient-rich water up onto the Mahé Plateau. The plateau is an area of relatively shallow water around 31,000km² (11,970 sq miles) in size that slopes off into the fathomless depths of the Somali Basin. The south-east upwellings force cold water up from the depths onto the sunlit shallows of the plateau. Once the plankton-rich water reaches the sunlight the algae photosynthesize rapidly, triggering a bloom of phytoplankton. This turns the usually clear blue water into a thick, green, planktonic soup. Zooplankton, which are microscopic planktonic

Right: A sub-adult male Whale Shark moves through dense plankton blooms.

FISHES

predators, ascend to gorge themselves on the phytoplankton bonanza. Filter-feeding leviathans such as Whale Sharks are lured in by this zooplankton banquet. The Whale Sharks that aggregate in Seychelles are predominantly sub-adult males 3–6m (10–20ft) in length. Aggregations of up to 30 individuals have been documented feeding together off the coast of Mahé, although individual animals are more commonly seen. When feeding in large aggregations, the sharks can often be seen using a 'ram feeding' technique. This is where the sharks swim quickly through a dense area of plankton with their mouths agape. Feeding in this way ensures that the largest fish in the sea consumes as much of its microscopic prey as possible.

The waters off the west coast of Mahé are often where the most concentrated densities of plankton are found, so in turn they boast the highest number of Whale Shark sightings during their seasonal visit to the islands, which peaks between August and October. Until recently, Seychelles was home to a long-running Whale Shark research project, with nearly 400 different individuals having been recorded by the Marine Conservation Society Seychelles (MCSS). Each shark is identified by a photograph taken of its side, specifically the area just behind the fifth gill slit. This area has a spot pattern that is unique to each animal, much like a fingerprint. Once the photographs have been obtained they are entered into a computer database using a pattern-recognition software program. This program was originally developed by NASA to identify star constellations. It was then modified for use in Grey Nurse Shark (*Carcharias taurus*) identification in Australia and is now the standard program for Whale Shark identification globally. The program measures the distance between individual spots in the photographs and compares the distances with the other existing spot patterns on the database. Whale Sharks travel great distances, and by identifying individuals in this way, researchers are able to track their movements across the Western Indian Ocean.

As the last of the Whale Sharks leave the Mahé Plateau to hopefully return again next year, female Sicklefin Lemon Sharks (*Negaprion acutidens*) secretly enter the shallow seagrass beds and coastal mangrove forests to give birth to their pups. From late September until December each year, the perfectly formed juvenile sharks are born and can be seen meandering through the submerged, twisted mangrove roots and fields of seagrass hunting for food. These critical coastal habitats provide the pups with protection from larger predatory sharks. Juvenile fishes also utilize the habitats, and in turn provide the pups with an abundant food source, thus creating an ideal nursery ground for the young predators.

A number of shark species inhabit Seychelles waters. The most commonly seen species around the granitic islands is the Whitetip Reef Shark (*Triaenodon obesus*). This nocturnal hunter spends much of the day resting under ledges created by granite boulders. Unlike other requiem sharks, which must swim constantly to breathe, Whitetip Reef Sharks can pump water over their gills in a process known as ram ventilation, allowing them to remain stationary on the sea floor. At night they emerge to feed on small bony fishes, their slender bodies enabling them to squeeze into impossibly small gaps in the reef in order to catch their quarry. Another nocturnally active shark is the Tawny Nurse Shark (*Nebrius ferrugineus*), a species of carpet shark that can grow to more than 3m (10ft) in length. Despite its size, it is incredibly docile and feeds on small bony fishes, crustaceans and other invertebrates, using a powerful suction technique to extract its prey from the sand and from crevices in the reef.

The cathedral-like granite rocks of Marianne Island provide the perfect backdrop for another commonly sighted requiem shark in the inner islands, the Grey Reef Shark (*Carcharhinus amblyrhynchos*). Distinguished by the broad black margin of the caudal fin, a round snout and large eyes, this is the archetypal shark. Grey Reef Sharks are a social species and frequently come together to form large schools. One such aggregation is found to the south of Marianne Island, although in recent years numbers have declined due to increased fishing pressure. In Seychelles, the local human population has practised shark fishing for centuries. Traditionally, the entire shark has been used, with shark meat one of the cheapest fish available at the market. Dried and salted, or sold fresh as fillets, it is often served in a Creole dish called *satini reken* (shark chutney), or in a curry with coconut milk.

Although it remains possible to see sharks while diving or snorkelling in Seychelles, their numbers have been significantly reduced. Early descriptive accounts indicate that there was once a very large population of sharks: 'But no [other] part [of the world] I have visited is so infested with sharks – the blue, the white, the tiger, the hammerheaded and indeed most of the varieties of that voracious tribe' (Captain Philip Beaver, 1805). Even as recently as the mid-twentieth century, large predatory sharks remained common in the inner islands, but after the Second World War the development of a targeted fishery soon began to impact on their numbers. Today species such as the Great Hammerhead (*Sphyrna mokarran*) and Tiger Shark (*Galeocerdo cuvier*) are extremely rare on the Mahé Plateau.

In response to declining shark stocks, the Seychelles Fishing Authority and the Ministry of Environment and Natural Resources published 'A National Plan of Action for the Conservation and Management of Sharks' in 2007. The aim was to ensure 'that shark stocks in the Seychelles EEZ

Above: Tawyny Nurse Sharks often spend daylight hours resting in caves. At night the species is an active hunter, using powerful suction to extract octopuses and small fish from crevices in the reef.

Previous page: A Tawny Nurse Shark swims along a reef wall at Alphonse Island. Nurse sharks are common throughout the archipelago, in part because their meat is considered of low value and consequently they are not targeted by local fishermen.

are effectively conserved and managed so as to enable their optimal long-term sustainable use'. The plan is currently in the process of being updated and will look to include recent international obligations (such as CITES) within its mandate.

While shark populations face uncertain futures, for some of the smaller residents of Seychelles coral reefs no such worries exist. Found among the numerous coral bommies that litter the carbonate and granitic reef systems of the Seychelles islands is a small, yet ubiquitous, brightly coloured coral reef fish. It forms clouds of orange and yellow, as numerous individuals dart in and out of coral outcrops, plucking zooplankton from the current. These are members of the Serranidae family, called anthias. They can shoal by the thousands, and within each group there are usually intimate subdivisions consisting of one very colourful, dominant male and up to 12 females, which also have their own hierarchy. This is known as a harem and will often include two subordinate males, which tend to be less flamboyant and not as territorial as the dominant male. It is common to see the dominant male performing an acrobatic dance, defending both his territory and females. Like many fishes, anthias are sequential hermaphrodites (they are able to change sex), and in the anthias' case they are protogynous hermaphrodites, being born female. This means that when a dominant male perishes, the largest female in the group often changes into a male to take its place.

To evade the scores of predators on the reef, many fish species have evolved ways to avoid becoming their next meal. One of these strategies is to adopt safety in numbers. On granitic reefs, the Bluestriped Snapper (*Lutjanus kasmira*) and Bengal Snapper (*Lutjanus bengalensis*) form large schools, engulfing ancient, submerged boulders as they move seamlessly around them. There are many advantages for the fishes in being part of such a large school. Firstly, the constant movement is very effective in confusing predators, while the markings of the numerous fishes combine to interfere with a predator's visual capabilities, making it extremely difficult for it to identify individual fish within the school. Schooling behaviour also plays a role in disrupting the ability of a predator's lateral line to detect prey. Unlike the fin movements of a single fish, which create an individual wave source, the electrical fields emitted by numerous fishes will overlap, giving the impression of a much larger animal. An additional benefit of being in a school is the presence of multiple sets of eyes, allowing the fishes to constantly scan their surroundings for would-be predators, as well as for potential sources of food. This extra vigilance allows more time for individual fish to feed, as they have others acting as their security guards. Schooling also increases the opportunity and ease of finding a mate, reducing the amount of energy and time it takes to locate a suitable partner. Various species of fusilier (Caesionidae), trevally (Carangidae) and soldierfish (Holocentridae), as well as the Slingjaw Mackerel (*Rastrelliger kanagurta*) and Seychelles Squirrelfish (*Sargocentron seychellense*), are all commonly encountered schooling or shoaling on the reefs of Seychelles.

Despite having safety in numbers, schools of fish do attract predators, and one of the most dramatic spectacles to witness underwater is Bluefin Trevally (*Caranx melampygus*) on the hunt. Dozens of these silver and blue bullets congregate in groups, which take turns speeding into schools of baitfish, dispersing them in every direction and picking off individuals in the blink of an eye. The steep underwater drop-offs around the atolls of the outer islands, such as those surrounding Alphonse and St François, provide ideal conditions for hunting trevally, and large packs of these hunters are often encountered patrolling the reef walls.

Another strategy used to escape the clutches of predators is to mimic other species that may be poisonous or distasteful, a tactic employed by many juvenile fishes. An example of this is seen in the Oriental Sweetlips (*Plectorhinchus vittatus*). The juvenile of this species mimics a toxic flatworm by swimming in a head-down undulating motion. With a dark body and large yellow-orange spots, resembling the flatworm, the little fish gives the impression that it is not safe to be eaten. This characteristic is called Batesian mimicry, and is a strategy employed by a number of otherwise defenceless species, which copy the appearance of organisms that are poisonous to predators. In doing so they are able to reduce the chance of being predated upon.

Juvenile fishes may also use intricate camouflage to mimic an inanimate object. Take the Orbicular Batfish (*Platax orbicularis*), for example; juveniles of this species mimic dead leaves, adopting a burnt-orange colouration, with mottled patterning on the body. They float in shallow brackish water on the edges of mangroves or in seagrass beds, drifting in the gentle surge and making themselves almost impossible to differentiate from leaves floating in the water. As the fishes grow older and larger, they lose their leaf-like appearance and become silver and disc shaped.

Right: Whitetip Reef Sharks are abundant around Seychelles. They are generally encountered underneath ledges and small caves during the day.

Predators can also use mimicry to their advantage. The Giant Frogfish (*Antennarius commerson*) inhabits areas of soft coral at granitic sites such as L'ilot Island, and provides an impressive example of this strategy. The first dorsal spine on the frogfish has evolved to form a modified fishing rod, known as an illicium. The lure at the end mimics a small fish or shrimp, which the frogfish dangles and jigs in front of its mouth, luring its prey to within striking distance. The frogfish also uses camouflage to ambush its prey and – depending on its chosen substrate – can change its colour to match the reef around it within a matter of weeks.

Scorpionfish also possess an effective camouflage strategy. They cannot readily change their colouration, but have an intricate lattice of mottled patterns and colours that mimic various substrates perfectly, making them incredibly difficult to see. As in frogfish, this camouflage allows them to effectively ambush their unsuspecting prey. Scorpionfish get their name from the highly venomous dorsal spines that run along the length of their back. These spines are an effective defence against predators, but can also deliver a very painful sting if accidentally touched by divers or snorkellers.

The fishes of Seychelles exhibit a diverse array of forms. They range in size from the miniscule to the massive and everything in between. While many are illusive, preferring to remain hidden from sight, others are inquisitive and gainfully seek out human interaction. Many species are active during daylight hours, while others prefer the cover of night. There are solitary species and those in which pairs form lifelong partnerships. In other species a dominant male presides over a group of females. Whether it is the ability to change sex, mimic an inanimate object or provide vital services for other reef dwellers, fishes have adapted to occupy every available niche within the competitive environment of the coral reef.

Left: Grey Reef Sharks are a social species that was once common throughout Seychelles' waters. Overfishing has led to a disappearance of the large aggregations, but smaller numbers of these sharks are still encountered both within the granitic and outer islands.

Above: A Marbled Stingray (*Taeniurops meyeni*) cruises over the reef at sunset, before spending the evening foraging for invertebrates and crustaceans in the sandy seabed.

Right: Manta rays are not a common sight in the inner island of Seychelles, although they are occasionally seen during the south-east monsoon, attracted, like the Whale Sharks, to the blooms of plankton.

FISHES

Above: A goatfish follows a Spotted Eagle Ray as it hunts for a meal. As the ray searches for molluscs within the sand, the goatfish remains nearby, ready to pick off small invertebrates.

Left: The Porcupine Ray (*Urogymnus asperrimus*) is listed on the IUCN Red List as Vulnerable. The tendency of this species to favour sandy, shallow-water habitats and to show high site fidelity has resulted in it being over-exploited by fisheries.

Following pages: Hundreds of anthias swirl around a coral bommie at Alphonse Island.

Page 110: Shark Bank is well known locally for its huge resident schools of Bengal Snapper. Tens of thousands congregate around the submerged granite boulders, engulfing divers as they pass through them.

FISHES

FISHES

FISHES

Above: Each day at dusk, dominant male anthias perform courtship dances to attract females from within their harem. Their frenzied performance of erratic swimming patterns leads to multiple spawning within the aggregation.

Right: Large numbers of Chevron Barracuda (*Sphyraena putnamiae*) can often be seen schooling at deeper reefs and pinnacles off the coast of Mahé.

Page 112: Paddletail Snapper (*Lutjanus gibbus*) form large schools over coral reefs.

Page 114: A school of mullet swims through the gin-clear waters of the Baie Ternay Marine National Park. Mullet are plankton feeders and spend much of their time swimming near the surface.

Page 118: The coral reefs surrounding Alphonse Island support a huge abundance of fish life. Packs of trevally scatter resident schools of Bluelined Snapper and Yellow Spot Emperors (*Gnathodentex aureolineatus*), as they hunt juvenile fusiliers.

Page 120: Orbicular Batfish school above the impressive granite rocks of Shark Bank, along with vast numbers of snappers.

FISHES

Left: Et qui sesuntis inihilicius se dolorest, ad moloribusba inicriis explibus accae num pererides sunt ra ctus ios
, sitibus pa venimoles molessim con rehenim fugiam nonem porrunt, tempudiciusa coreptatis quiate

122

Above: A scorpionfish sits motionless between vibrant soft corals, its texture and colouration blending in with its surroundings and assisting it in ambushing its prey.

Left: The Giant Frogfish is a master of camouflage, blending in effortlessly with its background. Like all frogfish it is an ambush predator, drawing in unsuspecting prey with a specially designed lure, before striking with lightning speed.

Above: A cleaner wrasse attends to a Blue Triggerfish (*Pseudobalistes fuscus*) at a cleaning station. The wrasse provide an essential service, removing parasites and dead skin from their client fish, while receiving a meal in the process.

Above: Bluestreak Cleaner Wrasse (*Labroides dimidiatus*) get to work removing parasites from a batfish.

Above: A juvenile Seychelles Anemonefish peeks out from the safety of its host anemone.

Left: The charismatic endemic Seychelles Anemonefish and its host anemone.

Following page: Giant Sweetlips (*Plectorhinchus albovittatus*) are rare within the inner granitic islands where they have been overfished. However, around Alphonse and St François Atolls, the species remains common and allows divers to approach closely.

FISHES

Above: A mixed school of sergeants congregates at the surface in search of a free meal. Tourists often throw small pieces of bread from a nearby hotel balcony and as soon as the morsels hit the water, dozens of ravenous fish rush towards them causing the water to boil.

Left: The juvenile Orbicular Batfish perfectly mimics a leaf in colour, texture and movement. Due to this unique camouflage technique, it can be extremely difficult for predators to distinguish it as a fish.

FISHES

Above: Although Emperor Angelfish (*Pomacanthus imperator*) are one of the more common species on Seychelles reefs, their colouration and markings make them one of the most exquisite reef fish species.

Above: The wrasse are a diverse family of marine fishes, which has over 600 species. The Checkerboard Wrasse (*Halichoeres hortulanus*) is a medium-sized fish common on Seychelles reefs. It takes its name from the distinctive pattern on the side of its body.

FISHES

Above: Whip Coral Gobies live exclusively on whip corals, utilizing them for protection and for a safe location on which to lay their eggs.

Left: The Longnose Hawkfish (*Oxycirrhites typus*) is usually found in association with sea fans or black coral at depths below 25m (82ft), making it rare within the granitic island group. The species is, however, extremely common on walls and the steep drop-offs of the coralline islands.

INVERTEBRATES

Those who have been lucky enough to dive in the azure waters around the Seychelles islands are likely to have been immediately captivated by the undulating granitic reefscapes, myriad of fish species and dramatic coral drop-offs. If they have taken the time to look a little closer they will have been rewarded with the sight of a group of marine organisms that make up one of the most abundant and intriguing on the planet. Diverse and adaptable, they are found throughout the coastal habitats of the Seychelles archipelago – they are marine invertebrates.

Left: Painted Rock Lobsters are usually found tucked underneath ledges, which they leave at night to feed.

INVERTEBRATES

Invertebrates make up more than 95 per cent of all animal species on Earth. They lack a backbone, so instead have evolved a range of different adaptations for structural support, including the development of a shell and the presence of a hard exoskeleton. Marine invertebrates were one of the first living animals on the planet, with some species dating back 580 million years. Of the 30 or so taxa that make up the group, Crustacea (lobsters, crabs and shrimp), Echinodermata (sea stars, brittle stars and sea urchins) and Mollusca (shellfish, squid and octopuses) are some of the most familiar.

Nudibranchs are soft-bodied marine gastropods, curious animals that have evolved to lose their shells. The word 'nudibranch' originates from the Latin word *nudus* and the Greek word *brankhia*, meaning naked gill. In most cases, the gills of a nudibranch are feather-like structures, located towards the posterior of the animal and designed to enhance the exchange of oxygen. Within the nudibranch family there are some of the most unusual body forms and exquisite colour combinations to be found in the animal kingdom. During the course of their evolution, nudibranchs have developed a range of defence mechanisms. One of the more typical examples is the exhibition of bright warning colours, which signal that an animal is potentially toxic. Another form of defence, employed by a variety of nudibranch species, is the production of a distasteful secretion, making them repellent to predators. To date, the nudibranchs of Seychelles have been poorly studied and there remains much to discover. However, approximately 100 nudibranch species have been recorded in the waters of Seychelles and although they can be found throughout the archipelago, the north-west of Mahé appears to be a particularly rich area for these charismatic little creatures.

The south-east monsoon is the most productive time of year to see nudibranch species in Seychelles. During this period the seagrass beds around the northwestern tip of Mahé experience population explosions of the Dorid Nudibranch (*Gymnodoris ceylonica*). Translucent in colour, with orange spots, it is a carnivorous species that feeds on small nudibranchs and sea hares. It is at this time of year that it begins to reproduce in only a few centimetres of water, and its yellow egg ribbons are often found festooned on seagrass blades like tinsel at Christmas.

Unlike nudibranchs, mantis shrimp possess rigid exoskeletons and must moult periodically in order to grow. There are approximately 500 species globally, with the largest growing up to 40cm (16in) in length. Their name is somewhat misleading, as they are not actually shrimp but instead belong to the order Stomatapoda, distinguished by having only three pairs of walking legs. They are solitary animals that construct

Right: On a coral reef in Beau Vallon, late in the afternoon, dozens of sea urchins undergo synchronized spawning. The clouds of eggs, which are released into the water column, provide a feeding bonanza for nearby reef fishes.

U-shaped burrows in the sandy substrate of the reef. The Peacock Mantis Shrimp (*Odontodactylus scyllarus*) is one of the most common mantis shrimp species in Seychelles waters, where it is often seen scurrying around the seabed, hunting for small fishes and other marine invertebrates. It gets its name from the stunning colouration of its exoskeleton, with males having vivid green-and-blue bodies, and vibrant red accents around the legs and head. A further characteristic of the Stomatapoda is the presence of specialized forearms called 'raptorial claws', which are used for capturing prey. The appendages are modified in design to be either blunt or spear-like, depending on the animal's food preference. Peacock Mantis Shrimp belong to the group known as 'smashers', and possess hammer-like appendages that are employed to break open the tough exterior shells of other invertebrates. These hammers can reach speeds of 23m/sec in water, equal to the speed of a .22 calibre bullet. The force of smashing at this speed creates cavitation bubbles between the mantis shrimp's appendages and the shell of its prey; this in turn generates a powerful shockwave, which breaks the shell open. Mantis shrimp tend to have an aggressive nature and will often defend their burrow, using their incredibly powerful forelimbs to fend off intruders. Photographers should beware when approaching mantis shrimp, as they have been known to break the glass on the external housing of an underwater camera.

Shrimp are a group of colourful crustaceans found throughout Seychelles' coastal habitats. They have narrow, muscular abdomens, and their fragile legs, which are predominantly used for perching, make them distinct from their crab and lobster cousins. Shrimp have developed pleopods or swimmerets, which move backwards and forwards extremely quickly, enabling propulsion. One particular shrimp species frequently encountered is the Hingebeak Shrimp (*Rhynchocinetes durbanensis*), which gets its name from its moveable serrated rostrum. Peer beneath a granite boulder or coral ledge and it is not uncommon to find an entire colony of these shrimp.

Due to their small size, shrimp and other marine invertebrates are highly susceptible to predation, and many species deploy a variety of strategies in order to survive. One such tactic is to live in a symbiotic association with another animal, where they can either take advantage of their host's defences or cryptically blend in with them. The Whip Coral Shrimp (*Dasycaris zanzibarica*), which mimics its coral host, is one such example of this association. This particular species is cryptic, an adaptation that assists it in avoiding detection from predators. The shrimp mimics the polyp structure of whip corals (*Cirrhipathes*), which are a part of the black coral family, Antipatharia. The shrimp are often found in pairs, and the female can grow to twice the size of the male.

Another interesting behaviour often witnessed on the reefs around Seychelles takes place at 'cleaning stations'. Many reef fishes, including groupers and moray eels, are vulnerable to external parasites, which burrow around the eyes and into the blood-rich lining of the gills and mouth. To keep these infestations under control, client fishes spend significant amounts of time at cleaning stations, where cleaner shrimp and cleaner fishes offer their services. There are multiple stations on a coral reef and they are usually located near prominent landmarks such as large coral outcrops. The cleaning stations are home to shrimp species such as the Banded Coral Shrimp (*Stenopus hispidus*) and the Clear Cleaner Shrimp (*Urocaridella antonbruunii*). When a fish is ready to be cleaned, it enters the small recesses that the shrimp typically inhabit. The client fish then remains still in an almost trance-like state, while the shrimp pick off parasites, dead skin and mucus. When the fish has had enough, it indicates to the shrimp that it is ready with a small movement of its fin or a turn of its body, and the shrimp retreats. These shrimp species have a symbiotic relationship with their client fish, which means that both parties benefit from the relationship. The shrimp receive a meal and in return the fishes get a good clean.

Symbiosis among marine invertebrates is not restricted to shrimp and reef fishes. Sea anemones have symbiotic relationships with several marine animals, including fishes, shrimps and crabs. Sea anemones are sessile polyps and have a column-shaped body. They attach to the substrate with an adhesive foot known as a basal disc and have a central oral disc in the middle of the body. In the centre of the oral disc is the mouth, which is surprisingly also the anus of the anemone. The mouth is surrounded by the anemone's most recognized feature, its tentacles. These are armed with cnidocytes, cells that are used in both defence and in the capture of prey. The cnidocytes contain stinging nematocysts, capable of injecting a dose of venom if triggered. Anemonefish, a few other fish species, and various shrimps and crabs are immune to these toxins and shelter within the tentacles of the anemone, in return providing protection from predators and parasites.

Right: *Glossodoris cincta* is a common and colourful nudibranch found around Seychelles.

Following page: *Goniobranchus albopunctatus* is one of the most vibrant nudibranch species found within the granitic islands of Seychelles. This species comes in two colour forms, with a red variation and a yellow colour morph.

INVERTEBRATES

141

Porcelain crabs such as *Neopetrolisthes maculatus* are often seen nestled among the stinging tentacles of sea anemones. They are filter feeders and possess long, fan-like mouthparts, which they use like a net to sweep small organisms, including planktonic algae and crustaceans, out of the water column. Unlike true crabs, porcelain crabs belong to the family Porcellanidae and have long antennae and a greatly reduced fourth pair of legs, which remain hidden beneath the carapace. An anemone unwittingly finds itself in a symbiotic relationship, as by coating itself in a sea anemone's mucus, a porcelain crab is able to deceive the anemone into believing it is part of the animal and thus avoid getting stung. In return for the protection offered by their living abode, the porcelain crabs will fend off potential home invaders from the host anemone.

There are numerous other examples of symbiosis on the reef. Sea cucumbers play host to a number of different species and form mutualistic relationships that benefit both the host and their associates. The Emperor Shrimp (*Zenopontonia rex*) is a small, colourful commensal shrimp often found living in association with a variety of sea cucumber species. This benefits a sea cucumber as the shrimp consumes any parasites found on its surface, while the shrimp, which is constantly traversing its host, profits by picking up food from the substrate that has been disturbed by the sea cucumber. Other invertebrate species that can be found in this mutualistic relationship with sea cucumbers are polychaete worms and the commensal crab *Lissocarcinus orbicularis*.

Holothurians, or sea cucumbers, are a key part of the coral reef ecosystem. They process large volumes of the sandy substrate, recycling nutrients and breaking down detritus and other organic matter. They are also a popular food item in certain parts of the world, and are consumed fresh or dried in various cuisines. In some Asian cultures the sea cucumber is believed to have medicinal value, and the Asian market for sea cucumber is estimated to be worth US$60 million per year. Sea cucumbers have been fished in Seychelles for more than 100 years and form part of the artisanal fisheries sector. Traditionally fishermen harvested sea cucumbers either by foot in shallow-water areas, or by using snorkelling equipment. Over time the demand for sea cucumbers, or *bêche-de-mer* in Creole, rose and there was a marked increase in the value of the product on the international market, creating an incentive to develop the fishery further. As the demand grew, so did the number of fishermen within the industry, and by 1999 there were already indications that numbers of sea cucumbers in shallow waters were in decline. Fishermen subsequently turned to scuba gear in order to collect sea cucumbers from deeper areas. The Seychelles Fishing Authority (SFA) now manages the fishery, offering a limited number of licenses each year.

Alongside the sea cucumber fishery, the SFA is also responsible for managing the artisanal lobster fishery. One of the larger marine invertebrates, lobsters can live to more than 100 years and must shed their carapace regularly in order to grow. The Painted Rock Lobster (*Panulirus versicolor*) is one of several species found on coral reefs in the inner islands, where it remains hidden under large granitic boulders during daylight hours. The permitted season for fishing lobster varies each year, but usually lasts for three months between December and February. The fishery sometimes closes for successive seasons to allow the lobster population to repopulate naturally, with the SFA using catch data as a tool to regulate the fishery.

Another frequently targeted invertebrate in the local fishery is octopus. Octopuses are common on coral reefs throughout Seychelles, often seen peering out of their holes, waiting for a quiet moment to slip out and begin hunting for their favoured prey of small invertebrates and crustaceans. The usual method for catching octopuses in Seychelles is with a sharpened metal stick while snorkelling. On the more populated islands, octopus fishermen are regularly seen returning from the reef with their catch, to be sold for use in traditional octopus curry. The species encountered in Seychelles waters is the Common Reef Octopus (*Octopus cyanea*). Predominantly active during the day, their dens can be located by the presence of discarded mollusc and crustacean shells piled up in front of them. Arguably the most intelligent of all the invertebrate animals, octopuses are able to perform incredible camouflage defence mechanisms, aided by specialized skin cells, which can change colour, opacity and texture in an instant. The cells are called chromatophores and contain a range of pigments. This colour-changing ability can also be used to communicate with other octopuses, either to signal danger or to begin a courtship ritual.

Left: The sap-sucking slug, *Cyerce nigricans*, is capable of producing a distasteful secretion, making it repellent to fishes. A common species, it is frequently found in shallow water, where it feeds on the algae *Chlorodesmus fastigiata*.

Above: *Gymnodoris ceylonica* – these colourful little nudibranchs are seen in large numbers at the beginning of the south-east monsoon. They mate and lay bright orange egg ribbons in shallow seagrass beds.

Above: This nudibranch is only 5mm (¼in) long and the occasion when it was photographed was possibly the first time this species has been found in Seychelles.

INVERTEBRATES

In order to reproduce, octopuses copulate in a very unusual way. Males possess a specialized arm called a hectocotylus, which transfers packets of sperm, or spermatophores, into the female's mantle cavity through one of two siphons. These siphons are used to breathe, expel waste and push out jets of water for swimming. The final destination of the spermatophores is the oviducal gland, an area in which the eggs are stored. When a female is ready to lay the eggs, the sperm will pass through and fertilize them. A female octopus can keep the sperm alive inside her for weeks or even months until her eggs are mature enough to lay. After laying, she ardently tends to the eggs, ensuring that they are aerated and devoid of algae. Once they finally hatch, she dies exhausted and starving, having expended all of her energy presiding over the birth of her offspring.

One group of marine invertebrates, which is currently under consideration for future exploitation in Seychelles, is the sea urchins. They belong to the Echinodermata, an intriguing phylum of 6,000 marine animals that also includes sea cucumbers and sea stars. Echinoderms take their name from the Greek words *echinos* and *derma*, literally meaning 'spiny skin'. Sea urchins lack a head and are radially symmetrical; they are made up of calcareous plates that form an endoskeleton, which supports their many spines. Sea urchins play an important role in the benthic ecosystem, and through grazing they assist with keeping algal cover under control. This helps to increase biodiversity on the reef, by maintaining the conditions necessary for coral colonies to reproduce and recover following acute disturbances like extreme storms or bleaching events. However, while a certain number of sea urchins are important for a healthy reef system, too many can be detrimental and impede coral recruitment, reduce cover of important coralline algae and lead to unsustainable bio-erosion.

The marine invertebrates are an amazingly diverse and charismatic group of animals. They are found in virtually every available habitat, where they employ a seemingly endless number of innovative survival strategies, which have enabled them to flourish. They are integral components of a healthy marine environment, responsible for filtering seawater, removing parasites, and breaking down dead and decaying organisms. Frequently ignored and often overlooked, the marine invertebrates are undoubtedly the unsung heroes of the coastal ecosystems of Seychelles.

Right: Peacock Mantis Shrimp have some of the most complex eyes in the animal kingdom, and can see both ultraviolet and polarized light. They have what is known as 'trinocular vision', enabling them to see objects with three different parts of the same eye.

INVERTEBRATES

INVERTEBRATES

Above: A close-up of the eyes of a Hingebeak Shrimp.

Right: Popcorn Shrimp (*Thor amboinensis*) can often be seen around *Physogyra lichtensteini* bubble corals.

INVERTEBRATES

INVERTEBRATES

Above: A commensal shrimp hitching a ride on a Crown-of-thorns Seastar.

Above: This cryptic little shrimp is only about 1cm (⅓ in) in length and lives exclusively on whip corals.

INVERTEBRATES

Above: The Peacock Anemone Shrimp (*Periclimenes brevicarpalis*) is one of the many invertebrates that inhabit various species of anemone.

Above: A commensal Sea Cucumber Crab (*Lissocarcinus orbicularis*) and its host sea cucumber benefit from a mutualistic relationship.

Following page: A feeding porcelain crab plucking planktonic morsels from the current.

Above: Branching corals play host to many different species, including this tiny coral crab.

Right: A large reef squid hanging mid water in the inky blackness of night.

Following page: A pair of octopuses mating within the Baie Ternay Marine National Park. Octopuses mate when the male inserts spermatophores into the female's mantle, using a specialized arm.

INVERTEBRATES

Above: An alien-like Common Reef Squid (*Sepioteuthis lessoniana*) hovers overhead like a UFO.

Above: Christmas Tree Worms (*Spirobranchus giganteus*) burrow into boulder corals and will quickly retract into their tubes if startled.

MARINE PROTECTED AREAS

The International Union for Conservation of Nature (IUCN), defines a Marine Protected Area (MPA) as 'Any area of the intertidal or sub-tidal terrain, together with its overlying water and associated flora, fauna, historical and cultural features, which has been reserved by law or other effective means to protect part or all of the enclosed environment'.

Left: The Curieuse Island Marine National Park incorporates Curieuse Island, the fifth largest of the granitic islands, and its surrounding waters. The park's beaches are important nesting grounds for Hawksbill Turtles, while juvenile sharks and rays utilize the mangrove forest and seagrass beds.

MARINE PROTECTED AREAS

Oceans cover over two-thirds of our planet. They produce more than half of the oxygen in the atmosphere and are home to some of the most diverse ecosystems on Earth. Not only do they support fisheries that provide the primary source of protein for over a billion people, but also three-quarters of the global tourism sector is concentrated on coastal zones. Our oceans are the lifeblood of our planet, but unfortunately an expanding global population has placed increasing pressure on these precious resources. Since the industrialization of fishing, many fish stocks have plummeted, and today more than 80 per cent of the world's fisheries are overexploited. Coastal development and habitat destruction are leading to the loss of vital ecosystems such as mangroves, seagrass beds and coral reefs. To make matters worse, we dump an estimated 8 million tonnes of rubbish into the oceans each year. For decades, natural resource managers and conservationists have been advocating the protection of a greater percentage of our oceans, setting aside certain areas where marine life is free from exploitation. We are now on the edge of a precipice where if we do not to embrace significant protective and restorative measures soon, it is likely that we will experience irreversible changes in the world's oceans.

MPAs can encompass a variety of habitats and provide a safe haven for a multitude of species located within their boundaries. If well managed, they can help sustain local fisheries and enhance areas for recreation and tourism. There are a number of terms used to describe MPAs, including Marine Reserves, Marine National Parks (MNPs) and Marine Parks (MPs). Within Seychelles there are different types of MPA. Marine National Parks and Special Reserves include no-take zones, while there are also fisheries management protected areas and shell reserves.

According to the Seychelles National Parks and Nature Conservancy Act (1969) a Special Reserve is 'an area set aside in which characteristic wildlife requires protection and in which all other interests and activities are subordinated to this end'. The granitic islands of Aride and Cousin are both Special Reserves, and are managed by local NGOs. Aride is the northernmost island of the granitic inner island group. The island covers an area of roughly 0.68km² (¼ sq mile) and is 1.6km (1 mile) long and 0.6km (1,968ft) wide. More than a million seabirds breed on the island, including the world's largest colonies of Lesser Noddy (*Anous tenuirostris*) and Tropical Shearwater (*Puffinus bailloni*), making it one of the most important seabird populations in the Indian Ocean. Aride is managed by the Island Conservation Society (ICS), whose aim is to 'promote the conservation and restoration of island ecosystems,

Right: At certain times of the year, huge schools of baitfish gather in shallow bays. The fishes provide food for numerous predators, including sea birds and other reef fishes.

Above: The Special Reserve of Aride is rat free, making it an important nesting ground for seabirds such as this White Tern (*Gygis alba*) chick.

MARINE PROTECTED AREAS

Above: *Coenobita brevimanus* is a large hermit crab that has experienced a decline in numbers on many of the larger islands. Within the Cousin Island Special Reserve, the crab is thriving in the absence of introduced predators.

169

sustainable development of islands, and awareness of their vulnerability and vital importance to the planet's biodiversity'.

The nearby island of Cousin is under the management of local NGO Nature Seychelles. This tiny island is home to large colonies of seabirds, alongside several endemic landbird species. It is widely regarded as one of Seychelles' conservation success stories, having seen a significant increase in the number of nesting Hawksbill Turtles since the island was afforded protection in 1975. The island was previously a dense coconut plantation, but due to an intensive restoration programme it is once again dominated by native species of flora.

Aldabra Atoll is the furthermost of the outer islands and is in fact closer to Madagascar than to Seychelles' inner granitic islands. This Special Reserve is also a UNESCO World Heritage Site and has the world's largest population of giant tortoises. The atoll's lagoon and surrounding waters are home to high densities of sharks and predatory fishes, as well as the Western Indian Ocean's largest number of nesting Green Turtles, a testament to their isolation and many years of protection.

The six Marine National Parks of Seychelles are all located within the granitic inner island group, and are managed by the Seychelles National Parks Authority (SNPA), which is responsible for all of the marine and terrestrial national parks of Seychelles.

On the north-west coast of Mahé, nestled between the towering hills of the Morne Seychellois National Park and Cap Matoopa, is the Baie Ternay Marine National Park. Designated as an MNP in 1979, it covers an area of 0.8km^2 (⅓ sq mile) and is a place of unparalleled beauty and biodiversity. Under the management of the SNPA, Baie Ternay includes some of the most intact coastal ecosystems that remain within the inner islands. The sweeping beach is bordered by vast seagrass beds, which provide the perfect nursery ground for juvenile sharks and fishes. Beyond theese lies a vibrant coral reef. Juvenile Green and Hawksbill Turtles take refuge in the shallow coral gardens, while Spotted Eagle Rays (*Aetobatus ocellatus*) and Porcupine Stingrays (*Urogymnus asperrimus*) forage for crustaceans in the sand. The Baie Ternay MNP is a popular destination for divers and snorkellers alike. In order to maintain the park, the SNPA charges a small fee, which contributes towards operating costs including ranger patrols and mooring buoy maintenance.

To the east of Victoria, the capital city of Seychelles, is the Sainte Anne MNP. Designated in 1973, it was the first MNP in the Western Indian Ocean and positioned Seychelles at the forefront of marine protection in the region. The St Anne MNP covers a total area of 13.85km^2 (5½ sq miles) and includes six islands – St Anne, Cerf Island, Île Cachée, Round Island, Moyenne Island and Long Island. The island of St Anne, to which the park owes its name, is the largest in the group. Hawksbill Turtles frequent the white sand beaches during the turtle-nesting season, and despite the island's close proximity to the Port of Victoria, its vibrant coral reefs support plenty of fish life.

Further parks were created in 1979 with the designation of the Port Launay MNP and Curieuse MNP. Lying approximately 2km (1¼ miles) to the north-east of Praslin Island, Curieuse Island was previously a quarantine area for leprosy sufferers. Today it is one of only two islands on the planet that is home to a natural population of the endemic Coco de Mer palm. On the eastern side of the island is Baie Laraie. The bay is bisected by a remnant sea wall, which was built in 1909 when Curieuse Island was privately owned, and was constructed in an attempt to rear Hawksbill Turtles to harvest in order to trade their shell. The project, however, was unsuccessful and was abandoned soon afterwards. Part of the causeway was destroyed by a tsunami in 2004, and the remaining wall stretches across Baie Laraie, forming an artificial lagoon that is now an important nursery ground for juvenile Sicklefish Lemon Sharks.

In the late 1980s and '90s another two MNPs were created. Silhouette, the third largest granitic island in Seychelles, which lies 12km (7½ miles) north of Mahé, was established in 1987, and a decade later, in 1997, the Ile Cocos MNP was established.

The Marine National Parks of Seychelles are all subject to the same rules and regulations, with only restricted use of pleasure craft and licensed tourist boats allowed. To help protect the fragile coral reef ecosystems, mooring buoys have been installed in all of the MNPs, and anchoring is only permitted in areas devoid of coral. Furthermore, the parks are strict no-take zones, where any type of fishing and the collection of wildlife are prohibited. This includes the removal of soil, sand and other substrates, and fines are issued to anyone guilty of an offence.

For an economy that is heavily reliant on tourism, the MPAs in Seychelles are a crucial source of revenue for local businesses. There are around a dozen scuba-diving centres and many more boat operators in the inner islands, offering a variety of diving and snorkelling trips, while liveaboards and cruise ships make regular visits to Aldabra Atoll and the Special Reserves in the inner islands. The opportunity to experience intact marine ecosystems, with bustling reefs and keystone species, is one of the key factors in Seychelles' appeal as a tourism destination. To further explore these tourism opportunities, a number of local NGOs offer voluntourism placements, allowing paying participants to obtain practical field experience in marine conservation while contributing to long-term scientific research programmes. Low-impact, high-value marine tourism such as this has the capacity to capitalize on these resources while contributing to their ongoing protection. Ensuring that

Left: A thriving reef scene in the Port Launay Marine National Park.

healthy marine ecosystems continue to flourish yet remain accessible is now an important part of the nation's sustainable tourism strategy.

The importance of Marine Protected Areas should not be underestimated to Small Island Developing States (SIDS) such as Seychelles. Setting aside coastal areas for protection, in which there are minimal anthropogenic disturbances, is integral to maintaining healthy, functioning ecosystems. A study of more than 120 marine reserves around the globe has shown that MPAs can result in average increases of 21 per cent in the diversity of species and 28 per cent in the size of fish, invertebrates and other organisms. In the right conditions, MPAs have been shown to harbour significantly more biomass (the total weight of marine life) than is found in unprotected areas.

Placing no-take restrictions on areas of coral reef can also mitigate against the negative effects of overfishing. A decline in the population of top predators can have a cascading effect on the entire coral reef food web. The establishment of MPA networks provides opportunities for both the replenishment of fish stocks and restoration of degraded habitats through connectivity. Also, by reducing the anthropogenic stress placed on a marine ecosystem, nature-based adaptation strategies can increase the chances of building resilience and maintaining the recovery potential of a reef system. On protected coral reefs, exploited fishes such as groupers and snappers have time to mature and grow. With a denser population of larger, older fishes, there is more opportunity for these fish groups to spawn and replenish their populations, as bigger, mature fishes produce significantly more eggs compared to their younger counterparts.

In addition to offering protection to species and habitats within their boundaries, MPAs have been known to increase fish stocks in adjacent fishing grounds. The 'spillover effect' is a term used to describe the movement of fishes (and also eggs and larvae) from a protected area into a neighbouring unprotected and potentially fished area, as a result of an increase in fish biomass and density within the MPA. This effect only happens over a period of time and in well-managed areas that are not subjected to illegal fishing activities. This is not only good news for surrounding coral reefs, but for local fisherman too.

The majority of the Seychellois people depend on the ocean for their livelihoods either directly or indirectly. MPAs have been used as a marine conservation tool in Seychelles for more than four decades, yet figures show that fish catches are declining. Fishermen are having to travel further afield to catch fishes, and are fishing longer to meet the increasing demand for their resources. Globally only 4 per cent of the world's oceans are under protection, which is a long way off the 30 per cent needed for healthy marine ecosystems.

In order to tackle this particular issue, Seychelles is embarking on an ambitious Marine Spatial Planning (MSP) initiative, which will look to manage the health of its ocean and plan for the long-term sustainable use of the nation's EEZ. The multi-sector process is a partnership between the Nature Conservancy, the Government of Seychelles and the United Nations Development Programme – Global Environment Facility Programme Coordinating Unit. The inclusion of multiple stakeholders in a participatory approach to the MSP process allows for transparency when attempting to minimize conflict between uses. The MSP will look to set aside 30 per cent of the EEZ for protection, of which 15 per cent will be no-take zones. This is a significant increase from the 0.04 per cent of Seychelles waters that are currently protected, and will include areas of high biodiversity and ecological value.

The initiation of the MSP process comes at a critical time, as the effects of human-induced climate change are being increasingly felt on both local and global scales. With a growing population, a rise in the number of annual visitors and increasing quantities of fish being exported, it is imperative that ocean resources are managed effectively to ensure sustainability. As the Seychelles government looks to exploit the vast potential of the country's EEZ through the implementation of the Blue Economy concept (an initiative aimed at maximizing revenue generated from marine-based activities), it is reassuring to know that a significant proportion of the nation's marine environment will be protected for future generations.

Right: Healthy and diverse corals in the shallows of Baie Ternay Marine National Park.

Previous page: Schools of baitfish gather in the shallow margins of Baie Ternay Marine National Park.

Following page: A Green Turtle takes a break amongst a diverse array of hard and soft corals in the heart of the Baie Ternay Marine National Park.

MARINE PROTECTED AREAS

MARINE PROTECTED AREAS

Above: A trio of Spotted Eagle Rays foraging in the seagrass beds of the Baie Ternay Marine National Park.

Right: Baitfish school in a small cave, whilst large squirrelfish circle waiting to pick off unsuspecting individuals.

MARINE PROTECTED AREAS

MARINE PROTECTED AREAS

Above: Soft corals and sea fans encrust the granite boulders of Port Launay Marine National Park.

Left: A Skunk Anemonefish (*Amphiprion akallopisos*) peers out of its host anemone

Following page: In late afternoon, the sun's rays penetrate the shallow water of the Baie Ternay Marine National Park. Sunlight is crucial for photosynthetic algae, known as zooxanthellae, which are found inside coral polyps and are responsible for coral growth.

CONSERVATION

Of all the challenges facing Small Island Developing States (SIDS) today, climate change is perhaps the most pernicious. Seychelles, like many SIDS, is particularly susceptible to the effects of climate change in its coastal areas. The islands' remoteness, a growing population and its economic dependence on fisheries and tourism, all contribute towards this vulnerability. In the future, increased sea temperatures and ocean acidification are predicted to impact significantly on coral reef ecosystems, while sea-level rises will threaten mangrove forests and accelerate coastal erosion. Many of these impacts have already been felt at the local level on some of the nation's islands.

Left: A Sicklefin Lemon Shark pup swims close to shore within the Curieuse Island Marine National Park. While this behaviour enables the young sharks to avoid larger predators associated with deeper water, they are unfortunately still easy targets for fishermen once they move to shallow waters outside of the protected area.

In 1998 a coral bleaching event triggered by elevated sea temperatures and associated with an El Niño Southern Oscillation climate event led to mass coral mortality in Seychelles' inner granitic islands, and an estimated 90 per cent reduction in hard coral cover. Over the next 17 years the reefs slowly began to recover, and eventually in 2015 reached pre-1998 levels of hard coral cover. The recovery was not uniform, however, and coral cover remained low on certain reefs, replaced instead by macroalgae or fields of coral rubble. The overall picture, though, was promising, and many of the reefs along northwest Mahé (an area that is heavily utilized by the diving industry) had made a full recovery.

Then, in 2016, another global coral bleaching event was to overturn the many years of excellent recovery made on Seychelles' reefs. It was not a complete surprise, as the bleaching event had been predicted by the National Oceanic Atmospheric Administration (NOAA), a scientific agency in the USA with a research focus on oceans and the atmosphere. An El Niño event had been observed to start in 2015, and reefs in the Pacific Ocean were already suffering acutely. By April 2016, when the Great Barrier Reef in northern Queensland was making the headlines around the world, the coral reefs of Seychelles were also being hit hard. After a sustained period of elevated sea surface temperatures, some corals began to turn ghostly white. May brought no respite as sea surface temperatures remained high, more corals lost their colour and the first coral mortality was recorded. By June, virtually all coral genera were displaying some degree of bleaching, and there was significant coral mortality on reefs throughout the archipelago.

The full extent of the impact of the 2016 coral bleaching event on the reefs of Seychelles is not yet fully understood. Long-term coral reef monitoring programmes, such as that undertaken by Global Vision International (GVI), in collaboration with the Seychelles National Parks Authority (SNPA), have been studying the reefs of north-west Mahé for more than a decade. The data collected under this programme will be invaluable in providing an assessment of the current health of coral reefs in the area, following the latest bleaching event. In recent years several organizations have also started collecting data from various locations throughout the EEZ, helping to build an overall picture of the status of Seychelles' coral reefs.

Initial indications are that coral mortality from this 2016 bleaching event was again most significant within the inner island group, and it was the fast-growing *Acropora* and *Pocillopora* corals that were most affected. It appears that colonies of some genera, such as massive *Porites* and foliose *Echinopora* corals, were on the whole spared. Although this provides hope that the reefs may recover again in time, it is likely that these coral communities will change and become dominated by more resistant non-coral species. Furthermore, there is concern that in the face of climate change, coral bleaching events will become more frequent and severe in future, hampering this recovery process.

Despite the high levels of coral mortality on many reefs, pockets of resilience have been identified. At Little Frégate, a granite reef situated a couple of kilometres from Frégate Island, an area the size of a football pitch remains apparently untouched by the coral bleaching event. Large, healthy colonies of branching *Acropora* and *Isopora* continue to dominate the reefscape. Similar cases are being reported from the outer islands. Within the Alphonse Group, the coral reef, which runs along one side of Alphonse Island, appears to have survived mostly unscathed. Coral reefs and individual colonies such as these, which for whatever reason appear resilient to thermal stress, will have a crucial role to play in the recovery of neighbouring reefs by potentially providing the genetic material necessary for future coral recruitment.

Recent research has found that while some reefs have shown resilience to degradation caused by climate-induced mass coral bleaching events, others have undergone phase shifts from coral to macroalgae or rubble-dominated environments. Once in this altered state, it is extremely difficult for these reefs to recover without human intervention. Rather than relying on isolated pockets of resilience to instigate coral reef recovery, active measures such as coral reef rehabilitation are currently being undertaken by several local organizations with the aim of speeding up the recovery process. One such flagship project is the UNEP Ecosystem Based Adaptation Project, which aims to 'strengthen the resilience and adaptive capacity of communities that depend on coastal ecosystem services provided by coral reefs and associated ecosystems'. The coral reef rehabilitation component of this project is being undertaken in the most visited Marine National Park in Seychelles, Curieuse Island.

The SNPA, alongside the Ministry of Environment, Energy and Climate Change, is responsible for implementing this coral reef rehabilitation project. The objective is to rehabilitate small sections of reef that have a high socio-economic value (such as those used for snorkelling) and have been damaged by the coral bleaching events.

Initially, the project tried to mitigate against future climate change effects in its design, by sourcing coral fragments from sites that were exposed to high water temperature and UV exposure. However, the 2016 mass coral bleaching event killed 97 per cent of corals in the nurseries. On a more positive note, the bleaching event enabled the scientists and coral gardeners to identify resilient coral colonies, which persisted in the abnormally warm water while others around them

CONSERVATION

Above: At the height of the coral bleaching event in 2016, many of Seychelles' coral reefs turned a ghostly white, like a snowy Christmas scene, as the symbiotic zooxanthellae algae left their coral hosts. It is these zooxanthellae that give the corals their colour, and if they do not return within a certain period of time, their coral host will starve and eventually die.

Following page: When corals bleach it is not unusual for them to fluoresce, turning shades of purple, pink and yellow. The exact cause for this is not clear but makes the deathly white appearance of the bleached reef even more startling.

CONSERVATION

perished. The rehabilitation team is now selecting these resilient corals for propagation, in the hope that they will be more likely to survive future coral bleaching events.

To date, 10,000 fragments of coral have been grown on metal frames and rope nurseries in the Curieuse Marine National Park. The majority of the fragments are fast-growing *Acropora* and *Pocillopra* branching corals, although several other genera have also been used. Each day divers working on the project visit the nursery and remove filamentous turf algae, which builds up on the ropes and frames, to ensure optimal conditions for the growth of the coral fragments.

Once the corals have reached a suitable size they are transferred to rehabilitation sites located in the park and around Praslin Island. The corals are fixed to the substrate with epoxy resin, helping to speed up the recovery process of the damaged reefs. The team behind the project is optimistic that it will prove to be a success and is creating a restoration techniques manual. It is hoped that this will act as an industry standard that can provide guidance and best practices for others wishing to become involved in active rehabilitation programmes.

Another organization to have already launched a coral reef restoration project locally is WiseOceans Seychelles, in collaboration with the Four Seasons Resort Seychelles. The aim of the project is to restore 10,000m^2 (107,639ft^2) of degraded limestone reef at Petite Anse, through the transplantation of 16,000 coral fragments.

Broken coral fragments are collected from the sea floor and fixed to a solid surface in the nursery to 'grow out'. So as to maintain genetic diversity, and to target resilient colonies, small pieces of coral are also snipped from live donor colonies within the area. Within a few months, the coral fragments are of a sufficient size to be transplanted to the outer reef, where they are fixed to the substrate.

In addition to restoring the coral reef at Petite Anse, the project aims to increase knowledge and awareness of coral reefs and the threats they face, through guest experiences, social media campaigns and innovative outreach tools. WiseOceans believe that through education and positive engagement, such strategies have the capacity to instigate real change on a local and global level.

In recent years, it is not solely coral bleaching events that have been responsible for a decrease in hard coral cover in Seychelles. In 2014 there was a Crown-of-thorns Seastar (*Acanthaster planci*) outbreak in the inner islands, which was particularly severe along the north-west coast of Mahé. Crown-of-thorns Seastars (COTS) are echinoderms, belonging to the same group of animals as sea urchins and sea cucumbers, and are found throughout the Indo-Pacific. They are brightly coloured and usually range from 25 to 35cm, although larger individuals do occur.

The animal's arms are covered in numerous long, sharp spines, which contain venom capable of inflicting a painful wound.

At low densities, COTS are an integral part of the coral reef ecosystem. However, at high densities they can cause significant and lasting damage to scleractinian coral communities. They display strong feeding preferences for branching *Acropora* and *Pocillopora* corals (which coincidentally are also the coral genera most susceptible to coral bleaching) and feed by everting their stomachs, which secrete enzymes that dissolve coral tissue.

The precise reasons for COTS outbreaks remain unclear, and at present two competing hypotheses have been suggested. These are the removal of COTS predators such as triton trumpets, helmet snails and Humphead Wrasse (*Cheilinus undulatus*), or excess nutrient loading due to terrestrial run-off. Within the Seychelles context, the COTS outbreak was most pronounced along the north-west coast of Mahé Island, where both terrestrial run-off and overfishing remain significant issues.

In order to try and combat the COTS outbreak, stakeholders were invited to participate in small-scale COTS removal programmes. At the peak of the outbreak in 2015, diving centres, NGOs and government departments worked together to remove hundreds of COTS from reefs in the Beau Vallon area each week. The physical removal of COTS was later changed in favour of in-water injections, first with sodium bisulphate and later with household vinegar, in an attempt to reduce the effort required and ensure that the maximum number of COTS could be targeted.

Following the mass coral bleaching event of 2016, COTS numbers decreased alongside the reduction in coral cover. They did not disappear completely, however, and some remained present on the reef, switching from their preferred food source of branching corals to the coral colonies that remained, including boulder and encrusting lifeforms. Under the guidance of the SNPA, a COTS task force was established to systematically deal with this serious threat and attempt to reduce COTS numbers to natural levels.

One could be forgiven for feeling disheartened regarding the future health of Seychelles' marine environment, yet many initiatives are taking place that are beginning to provide positive results. Seychelles has a proud conservation history and the nation's environmental credentials are well known on the global stage. For many years the main focus of conservation initiatives was on terrestrial ecosystems, but in recent years there has been an increase in funding available for marine research and conservation. Today, the Ministry of Environment, Energy and Climate Change, alongside private enterprises and local

CONSERVATION

and international NGOs, is overseeing numerous projects that aim to gain a deeper understanding of the incredible marine life that inhabits the waters around the islands.

One such project is located on Curieuse Island, where GVI is studying the Sicklefin Lemon Shark (*Negaprion acutidens*) population in collaboration with the SNPA. Curieuse Island and its surrounding waters is a Marine National Park, and a strict no-take zone. It is home to one of the largest remaining areas of mangrove forest in the inner island group, and this acts as an important nursery area for juvenile sharks. Sicklefin Lemon Sharks are found throughout the Indo-Pacific, where they inhabit coastal and offshore waters to a depth of at least 30m (98ft). They are listed on the IUCN Red List of Threatened Species as Vulnerable, with a decreasing population trend. The species is extremely susceptible to overfishing, and in some parts of its range it has already become locally extinct. In Seychelles, adult Sicklefin Lemon Sharks pup between October and January each year, during which time the juvenile sharks can be seen swimming close to shore. At this time they are particularly vulnerable and are actively targeted by local fishermen.

On Curieuse Island, in theory Sicklefin Lemon Sharks should be protected from fishing in the mangroves and surrounding waters. The team at GVI is inserting Passive Integrated Transponder (PIT) tags into juvenile sharks. Each tag acts as a barcode enabling the researchers to scan individual sharks, providing them with information about recapture rates and growth data. The project is now using acoustic tracking methods to record the movements and habitat preference of juvenile sharks. This data will enable GVI to calculate the number of sharks using the nursery grounds, as well as to develop an understanding of their survival rates into adulthood. The information can also be used to understand more clearly the importance of setting aside areas for the protection of species, particularly with reference to critical early life stages.

These initiatives represent but a small fraction of the numerous programmes currently being conducted in an effort to preserve Seychelles' unique marine biodiversity. On a wider scale, the government-led Blue Economy concept and the Marine Spatial Planning initiative aim to maximize the sustainable use of Seychelles' EEZ, while simultaneously setting aside large areas of ocean for protection. Although significant challenges undoubtedly lie ahead, through the development of innovative strategies and implementation of adaptive solutions, the Seychelles government and environment sector are committed to ensuring that the protection of the marine environment remains at the forefront of the nation's development strategy.

Left: A diver lays a 50m (165ft) transect line to record the abundance and diversity of coral reef fishes within the Baie Ternay Marine National Park. This is part of a long-term coral reef monitoring programme, which is providing valuable information on coral reef resilience and recovery on Seychelles' reefs.

CONSERVATION

CONSERVATION

Above: The many arms of the Crown-of-thorns Seastar are covered in sharp, thorn-like spines that can deliver a painful sting. This keeps many would-be predators at bay and allows the seastars to graze unhindered on coral tissue.

Left: A pair of Crown-of-thorn Seastars hungrily feed on an *Acropora* table coral. The seastars have already consumed the coral tissue shown in the top of the image and the coral's bare skeleton has been rapidly colonized by algae, giving it its brown-green appearance.

Following pages: A healthy colony of *Acropora* sp. on a reef at Little Frégate. Those branching corals that survived the 2016 coral bleaching event act as magnets to fish species.

CONSERVATION

CONSERVATION

Above: A suspended rope nursery within the Curieuse Island Marine National Park stocked full of juvenile corals. Coral fragments are taken from a donor reef and attached to the ropes by project staff. Once they have grown to a sufficient size they are transplanted to a dedicated rehabilitation site.

Left: Crates of coral fragments taken by research staff from a donor reef outside the national park wait to be transferred to the rope coral nursery in the Curieuse Island Marine National Park. Where possible, loose fragments are taken from the donor reef so that the resilience of this reef also stays intact.

Page 198: Algae quickly colonize any bare surfaces on the reef and the metal bars to which the coral fragments are attached are no exception. WiseOceans project staff regularly clean the coral nursery to remove this build-up of algae, which can suffocate the corals and hinder their growth.

Page 199: An *Acropora* coral hangs from a rope nursery in the Baie Ternay Marine National Park. The small-scale reef rehabilitation initiative is one of several currently in place in Seychelles' inner granitic islands.

CONSERVATION

CONSERVATION

CONSERVATION

CONSERVATION

Above: A research scientist from Global Vision International (GVI) releases a newly tagged juvenile Sicklefin Lemon Shark. This tagging forms part of a long-term mark/recapture programme by GVI and SNPA, which will provide valuable data on growth rates for this vulnerable species.

Left: Large boulder corals litter the shallows around Anse Royale, Mahé. These corals have shown greater resilience against prolonged elevated sea-surface temperatures than the branching corals in the area, and subsequently did not suffer significantly during the last major bleaching event.

Following page: An Emperor Angelfish takes cover below a dead *Acropora* coral. Sponges and coral recruits are beginning to colonize the coral skeleton.

GLOSSARY

anaerobic Of an environment in which oxygen is absent.

angiosperm Flowering plant.

anthropogenic Originating in human activity.

autotrophic Capable of synthesizing a food supply from carbon.

azooxanthellate Lacking zooxanthellae.

Bodanmyen Or *Terminalia catappa*, a large, dry-season deciduous tree with edible fruits. Naturalized thoughout the Indo-Pacific region.

carapace Hard upper shell of a crustacean or marine turtle.

carbonate Of calcium carbonate in origin.

Cheloniidae Family of hard-shelled marine turtles.

CITES Convention on International Trade in Endangered Species of Wild Fauna and Flora.

cnidocyte Explosive cell found in corals, jellyfish and sea anemones (Cnidaria).

coral bommie Stand-alone coral outcrop, comprising an assemblage of coral colonies.

corallite Skeleton of an individual coral polyp.

diurnal During daytime.

dorid (of Doridoidea) Group of medium to large sea slugs, lacking shells.

echinoderm Phylum of radial symmetrical marine invertebrates, which includes sea stars, sea urchins and sea cucumbers.

ecosystem Community of living and non-living components interacting to form a functioning system.

El Niño Southern Oscillation Naturally occurring periodic phenomenon that involves fluctuating winds and sea surface temperatures in the tropical eastern Pacific.

endemic (of a plant or animal) Restricted to a particular geographic region.

epifaunal (of the marine environment) Organisms that live on the surface of the seabed.

extant Surviving; still in existence.

foliose (of coral) Lobed or leaf-like in structure.

Gondwanaland Ancient supercontinent of the southern hemisphere.

granitic Granite in nature. A coarse-grained igneous rock consisting mostly of quartz.

halotolerant Adapted to conditions of high salinity.

hectocotylus Modified limb found in some male cephalopods, used for transferring sperm to the female.

hermatypic Zooxanthellate, reef-building corals in the order Scleractinia.

heterogeneous Diverse.

infaunal (of the marine environment) Organisms that live beneath the surface of the seabed.

illicium Modified dorsal ray common in the order Lophiiformes.

inselbergs Isolated rock/hill that rises abruptly from a plain.

littoral zone Coastal area that remains above water at low tide and under water at high tide.

massive (in relation to coral) Boulder-like in structure.

morphologically Form and structure of an organism or its parts.

nematocysts Specialized stinging cells found in the tentacles of Cnidaria.

no-take zone Designated area where all types of fishing are prohibited.

orographic lift Process by which an air mass is forced upwards as it moves over rising terrain.

plastron Lower part of a turtle's shell.

photic zone Layer of the ocean in which organisms are exposed to sunlight.

photosynthesis Process in which light energy is converted into chemical energy.

Pneumatophore (of mangroves) Aerial root specialized for gaseous exchange.

requiem sharks Big group of sharks belonging to the family Carcharhinidae – a large family of mainly pelagic sharks.

rostrum Projection or extension of the snout in crustaceans.

scleractinian corals Hard or stony corals, the primary reef builders.

secondary forest Forested area that has regrown following the removal of the original forest.

sessile Attached to a substrate.

shoal Group of fishes that remain together for social reasons.

SIDS Distinct group of developing island nations facing similar economic and environmental challenges.

school Group of fishes swimming together in a coordinated manner.

symbiotic Interaction between two organisms living in close association.

Takamaka Or *Calophyllum inophyllum*, a large, slow-growing tree native to the Indo-Pacific region.

topography Shape and arrangement of a geographical area.

zooxanthellae Single-celled algae that live in the tissues of corals.

zooxanthellate Containing or pertaining to zooxanthellae.

SHOOTING EDEN

Underwater Eden is the result of 10 years of exploring the reefs, rivers, atolls, mangroves, coral cays and montane forests of the Seychelles archipelago. The idea for the book was conceived at a time when Cap Ternay, a location of personal significance to us both, was under the threat of development to accommodate a luxury hotel resort. Had the project proceeded, it would have involved dredging the Baie Ternay Marine National Park, with potentially damaging results for the sensitive marine ecosystems within its boundaries. We wanted to convey the importance of Baie Ternay as an example of one of the few remaining healthy, interconnected coastal ecosystems on Mahé Island, but also to highlight the incredible marine life found throughout the Seychelles. Fortunately the development did not go ahead, and for now the Baie Ternay Marine National Park continues to astound everyone with its natural beauty.

We met while working for an international conservation and community development organization with a marine research base located at Cap Ternay on Mahé Island. Our spare time was nearly always spent diving and snorkelling around the north-west coast of Mahé Island, photographing the incredible diversity of marine flora and fauna. Although we utilized scuba when necessary, the majority of the images captured in this book were shot on a single breath while free diving.

During the making of *Underwater Eden*, we experienced many unforgettable encounters, from coming face to face with the largest fish in the sea, to exploring freshwater streams in the forests of the Morne Seychellois National Park. We also experienced our fair share of problems – lost equipment, cracked camera housings, tropical diseases, and plenty of cuts and bruises. These minor issues, however, were all part and parcel of working in a challenging tropical environment such as Seychelles. We hope that in these pages we have managed to capture a small part of the adventure, wonder and beauty of this truly unique archipelago.

Pages 2–3
GLACIS, MAHÉ
Canon 7D, Tokina 10-17mm Fisheye
Nauticam Housing
f8, 1/60th, ISO 200
Joe Daniels

Pages 4–5
L'ILOT ISLAND
Canon 7D, Tokina 10-17mm Fisheye
Ikelite Housing, 2 x DS160 Ikelite Strobes
f9, 1/200th, ISO 200
Christophe Mason-Parker

Pages 6–7
ST FRANÇOIS ATOLL
Canon 7D, Tokina 10-17mm Fisheye
Ikelite Housing, 2 x DS160 Ikelite Strobes
f8, 1/250th, ISO 160
Christophe Mason-Parker

Pages 10–11
SHARK BANK, MAHÉ
Canon 7D, Tokina 10-17mm Fisheye
Nauticam Housing, 2 x Sea&Sea YSD1 Strobes
f8, 1/100th, ISO 100
Joe Daniels

Pages 12–13
THÉRÈSE ISLAND
Canon 50D, 10-22mm
Ikelite Housing
f11, 1/80th, ISO 200
Joe Daniels

Pages 14–15
MARIANNE ISLAND
Canon 7D, Tokina 10-17mm Fisheye
Ikelite Housing, 2 x DS160 Ikelite Strobes
f8, 1/160th, ISO 200
Christophe Mason-Parker

Pages 16–17
FRÉGATE ISLAND
Canon 7D, Tokina 10-17mm Fisheye
Nauticam Housing, 2 x Sea&Sea YSD1 Strobes
f8, 1/160th, ISO 200
Joe Daniels

Page 18
FRÉGATE ISLAND
Canon 7D, Tokina 10-17mm Fisheye
Ikelite Housing, 2 x DS160 Ikelite Strobes
f10, 1/160th, ISO 200
Christophe Mason-Parker

Page 19
DRAGON'S TEETH, MAHÉ
Canon 7D, 100mm macro,
Nauticam Housing, 2 x Sea&Sea YSD1 Strobes
f8, 1/200th, ISO 100
Joe Daniels

SHOOTING EDEN

Pages 20–21
FRÉGATE ISLAND
Canon 7D, Tokina 10-17mm Fisheye
Nauticam Housing, 2 x Sea&Sea YSD1 Strobes
f8, 1/125th, ISO 100
Joe Daniels

Page 22
MARE AUX COCHONS, MAHÉ
Canon 7D, Tokina 10-17mm Fisheye
Nauticam Housing, 2 x Sea&Sea YSD1 Strobes
f10, 1/60th, ISO 1250
Joe Daniels

Page 23
BAIE TERNAY MARINE NATIONAL PARK, MAHÉ
Canon 7D, Tokina 10-17mm Fisheye
Ikelite Housing, 2 x DS160 Ikelite Strobes
f16, 1/200th, ISO 200
Christophe Mason-Parker

Page 25
BIRD ISLAND
Canon 7D, Tokina 10-17mm Fisheye
Ikelite Housing, 2 x DS160 Ikelite Strobes
f10, 1/125th, ISO 100
Christophe Mason-Parker

Pages 26–27
SOUTH MARIANNE, MARIANNE ISLAND
Canon 7D, Tokina 10-17mm Fisheye
Ikelite Housing, 2 x DS160 Ikelite Strobes
f14, 1/125th, ISO 200
Christophe Mason-Parker

Page 29
BEAU VALLON, MAHÉ
Canon 7D, Tokina 10-17mm Fisheye
Ikelite Housing, 2 x DS160 Ikelite Strobes
f18, 1/160th, ISO 200
Christophe Mason-Parker

Pages 30–31
BEAU VALLON, MAHÉ
Canon 7D, Tokina 10-17mm Fisheye
Nauticam Housing, 2 x Sea&Sea YSD1 Strobes
f9, 1/15th, ISO 200
Joe Daniels

Pages 32–33
L'ILOT ISLAND
Canon 7D, Tokina 10-17mm Fisheye
Ikelite Housing, 2 x DS160 Ikelite Strobes
f13, 1/200s, ISO 200
Christophe Mason-Parker

Pages 34–35
FRÉGATE ISLAND
Canon 7D, Tokina 10-17mm Fisheye
Nauticam Housing, 2 x Sea&Sea YSD1 Strobes
f10, 1/200th, ISO 200
Joe Daniels

Pages 36–37
CERF ISLAND
Canon 7D, Tokina 10-17mm Fisheye
Nauticam Housing, 2 x Sea&Sea YSD1 Strobes
f22, 1/13th, ISO 100
Joe Daniels

Pages 38–39
BRISSARE ROCKS, MAHÉ
Canon 7D, Tokina 10-17mm Fisheye
Ikelite Housing, 2 x DS160 Ikelite Strobes
f8, 1/250th, ISO 200
Christophe Mason-Parker

Page 40
BEAU VALLON, MAHÉ
Canon 7D, Canon 100mm macro
Ikelite Housing, 2 x DS160 Ikelite Strobes
f14, 1/250th, ISO 200
Christophe Mason-Parker

Page 41
DRAGON'S TEETH, MAHÉ
Canon 7D, Tokina 10-17mm Fisheye
Ikelite Housing, 2 x DS160 Ikelite Strobes
f8, 1/250th, ISO 200
Christophe Mason-Parker

Pages 42–43
SHARK BANK, MAHÉ
Canon 7D, Tokina 10-17mm Fisheye
Nauticam Housing, 2 x Sea&Sea YSD1 Strobes
f6.3, 1/100th, ISO 100
Joe Daniels

Page 44
MARE AUX COCHONS, MAHÉ
Canon 7D, Tokina 10-17mm Fisheye
Nauticam Housing, 2 x Sea&Sea YSD1 Strobes
1/50th, f11, ISO 400
Joe Daniels

Page 45
ANSE DU RIZ
Canon 7D, Tokina 10-17mm Fisheye
Ikelite Housing, 2 x DS160 Ikelite Strobes
f11, 1/160th, ISO 200
Christophe Mason-Parker

Pages 46–47
MARE AUX COCHONS, MAHÉ
Canon 7D, Tokina 10-17mm Fisheye
Nauticam Housing, 2 x Sea&Sea YSD1 Strobes
1/50th, f11, ISO 400
Joe Daniels

Page 48
BAIE TERNAY MARINE NATIONAL PARK, MAHÉ
Canon 50D, Canon 60mm macro
Ikelite Housing, 1 x DS161 Strobe
f13, 1/200th, ISO 100
Joe Daniels

SHOOTING EDEN

Page 49
BEAU VALLON, MAHÉ
Canon 7D, 100mm macro
Nauticam Housing, 2 x Sea&Sea YSD1 Strobes
f22, 1/125th, ISO 200
Joe Daniels

Pages 50–51
ALPHONSE ISLAND
Canon 7D, Tokina 10-17mm Fisheye
Ikelite Housing, 2 x DS160 Ikelite Strobes
f8, 1/200th, ISO 200
Christophe Mason-Parker

Page 52
FRÉGATE ISLAND
Canon 7D, Tokina 10-17mm Fisheye
Nauticam Housing, 2 x Sea&Sea YSD1 Strobes
f8. 1/80th, ISO 200
Joe Daniels

Page 53
BIRD ISLAND
Canon 50D, Tokina 10-17mm Fisheye
Ikelite Housing, 2 x DS161 Strobe
f9, 1/125th, ISO100
Joe Daniels

Pages 54–55
MAHÉ
Canon 7D, Tokina 10-17mm Fisheye
Kenko 1.4 teleconverter
Nauticam Housing, 2 x Sea&Sea YSD1 Strobes
f20, 1/10th, ISO 100
Joe Daniels

Page 56
BAIE TERNAY MARINE NATIONAL PARK, MAHÉ
Canon 7D, Tokina 10-17mm Fisheye
Ikelite Housing, 2 x DS160 Ikelite Strobes
f11, 1/200th, ISO 200
Christophe Mason-Parker

Page 57
BAIE TERNAY MARINE NATIONAL PARK, MAHÉ
Canon 7D, Tokina 10-17mm Fisheye
Ikelite Housing, 2 x DS160 Ikelite Strobes
f11, 1/200th, ISO 200
Christophe Mason-Parker

Pages 58–59
ALPHONSE ISLAND
Canon 7D, Tokina 10-17mm Fisheye
Ikelite Housing, 2 x DS160 Ikelite Strobes
f8, 1/160th, ISO 160
Christophe Mason-Parker

Page 60
ANSE SOULIAC, MAHÉ
Canon 7D, Tokina 10-17mm Fisheye
Nauticam Housing, 2 x Sea&Sea YSD1 Strobes
f7.1, 1/250th, ISO 200
Joe Daniels

SHOOTING EDEN

Page 61
BAIE TERNAY MARINE NATIONAL PARK, MAHÉ
Canon 7D, Tokina 10-17mm Fisheye
Ikelite Housing, 2 x DS160 Ikelite Strobes
f9, 1/100s, ISO 400
Christophe Mason-Parker

Pages 62–63
ALPHONSE ISLAND
Canon 7D, Tokina 10-17mm Fisheye
Ikelite Housing, 2 x DS160 Ikelite Strobes
f8, 1/200th, ISO 200
Christophe Mason-Parker

Page 64
BAIE TERNAY MARINE NATIONAL PARK, MAHÉ
Canon 7D, Tokina 10-17mm Fisheye
Nauticam Housing, 2 x Sea&Sea YSD1 Strobes
f10, 1/60th, ISO 100
Joe Daniels

Page 65
BEAU VALLON, MAHÉ
Canon 7D, Tokina 10-17mm Fisheye
Nauticam Housing, 2 x Sea&Sea YSD1 Strobes
f10, 1/15th, ISO 200
Joe Daniels

Pages 66–67
ST FRANÇOIS ATOLL
Canon 7D, Tokina 10-17mm Fisheye
Ikelite Housing, 2 x DS160 Ikelite Strobes
f8, 1/200th, ISO 250
Christophe Mason-Parker

Page 68
BIRD ISLAND
Canon 7D, Tokina 10-17mm Fisheye
Ikelite Housing, 2 x DS160 Ikelite Strobes
f8, 1/250th, ISO 125
Christophe Mason-Parker

Page 69
BAIE TERNAY MARINE NATIONAL PARK, MAHÉ
Canon 7D, Tokina 10-17mm Fisheye
Ikelite Housing, 2 x DS160 Ikelite Strobes
f11, 1/250th, ISO 100
Christophe Mason-Parker

Pages 70–71
ALPHONSE ISLAND
Canon 7D, Tokina 10-17mm Fisheye
Ikelite Housing, 2 x DS160 Ikelite Strobes
f8, 1/200th, ISO 200
Christophe Mason-Parker

Pages 72–73
FRÉGATE ISLAND
Canon 7D, Tokina 10-17mm Fisheye
Ikelite Housing, 2 x DS160 Ikelite Strobes
f10, 1/160th, ISO 200
Christophe Mason-Parker

SHOOTING EDEN

Page 75
BAIE TERNAY MARINE NARIONAL PARK, MAHÉ
Canon 50D, Tokina 10-17mm Fisheye
Ikelite Housing
f11, 1/100th, ISO 320
Joe Daniels

Page 76
CURIEUSE ISLAND MARINE NATIONAL PARK
Canon 7D, Canon 10-18mm,
f11, 1/400th, ISO 400
Christophe Mason-Parker

Page 78
BIRD ISLAND
Canon 550D, Canon 55mm-250mm lens,
f5.7, 1/30th, ISO 800
Christophe Mason-Parker

Page 79
BAIE TERNAY, MAHÈ
Canon 50D, Tokina 10-17mm Fisheye
Ikelite Housing, 2 x DS161 Strobes
f18, 1/125th, ISO 100
Joe Daniels

Page 80
BIRD ISLAND
Canon 50D, Tokina 10-17mm Fisheye
Ikelite Housing, 2 x DS161 Strobes
f9, 1/250th, ISO 100
Joe Daniels

Page 81
BIRD ISLAND
Canon 7D, Tokina 10-17mm Fisheye
Ikelite Housing, single DS160 Ikelite Strobe
f11, 1/400th, ISO 160
Christophe Mason-Parker

Page 82
BIRD ISLAND
Canon 7D, Tokina 10-17mm Fisheye
Ikelite Housing, 2 x DS160 Ikelite Strobes
f13, 1/250th, ISO 125
Christophe Mason-Parker

Page 83
BIRD ISLAND
Canon 50D, Tokina 10-17mm Fisheye
Ikelite Housing, 2 x DS161 Strobes
f9, 1/250th, ISO 100
Joe Daniels

Page 84
FRÉGATE ISLAND
Canon 7D, Tokina 10-17mm Fisheye
Nauticam Housing, 2 x Sea&Sea YSD1 Strobes
f10, 1/125th, ISO 100
Joe Daniels

211

SHOOTING EDEN

Page 85
FRÉGATE ISLAND
Canon 7D, Tokina 10-17mm Fisheye
Nauticam Housing, 2 x Sea&Sea YSD1 Strobes
f14, 1/200th, ISO 200
Joe Daniels

Page 86
BEAU VALLON, MAHÉ
Canon 7D, Tokina 10-17mm Fisheye
Ikelite Housing, 2 x DS160 Ikelite Strobes
f8, 1/250th, ISO 200
Christophe Mason-Parker

Page 87
FRÉGATE ISLAND
Canon 7D, Tokina 10-17mm Fisheye
Ikelite Housing, 2 x DS160 Ikelite Strobes
f10, 1/160th, ISO 200
Christophe Mason-Parker

Pages 88-89
BAIE TERNAY MARINE NATIONAL PARK, MAHÉ
Canon 50D, Tokina 10-17mm Fisheye
Ikelite Housing, 2 x DS161 Strobes
f11, 1/125th, ISO 100
Joe Daniels

Page 90
BAIE TERNAY MARINE NATIONAL PARK, MAHÉ
Canon 7D, Canon 100mm macro
Ikelite Housing, 2 x DS160 Ikelite Strobes
f11, 250th, ISO 250
Christophe Mason-Parker

Page 91
BIRD ISLAND
Canon 7D, Tokina 10-17mm Fisheye
Ikelite Housing, single DS160 Ikelite Strobe
f11, 1/400th, ISO 125
Christophe Mason-Parker

Pages 92–93
THÉRÈSE ISLAND
Canon 50D, 10-22mm Ikelite Housing
f5, 1/80th, ISO 160
Joe Daniels

Pages 94-95
ANSE A LA MOUCHE, MAHÉ
Canon 50D, 10-22mm Ikelite Housing
f8, 1/100th, ISO 160
Joe Daniels

Pages 96–97
ALPHONSE ISLAND
Canon 7D, Tokina 10-17mm Fisheye
Ikelite Housing, 2 x DS160 Ikelite Strobes
f9, 1/160th, ISO 200
Christophe Mason-Parker

Page 99
ST FRANÇOIS ATOLL
Canon 7D, Tokina 10-17mm Fisheye
Ikelite Housing, 2 x DS160 Ikelite Strobes
f8, 1/200th, ISO 160
Christophe Mason-Parker

Page 101
LITTLE FRÉGATE ISLAND
Canon 7D, Tokina 10-17mm Fisheye
Nauticam Housing, 2 x Sea&Sea YSD1 Strobes
f8, 1/125th, ISO 200
Joe Daniels

Page 102
MARIANNE ISLAND
Canon 7D, Tokina 10-17mm Fisheye
Ikelite Housing, 2 x DS160 Ikelite Strobes
f8, 1/250th, ISO 200
Christophe Mason-Parker

Page 104
BEAU VALLON, MAHÉ
Canon 7D, Tokina 10-17mm Fisheye
Nauticam Housing, 2 x Sea&Sea YSD1 Strobes
f8, 1/50th, ISO 200
Joe Daniels

Page 105
BAIE TERNAY MARINE NATIONAL PARK, MAHÉ
Canon 50D, Tokina 10-17mm Fisheye
Ikelite Housing, 2 x DS161 Strobe
f11, 1/100th, ISO 100
Joe Daniels

Page 106
BAIE TERNAY MARINE NATIONAL PARK, MAHÉ
Canon 7D, Tokina 10-17mm Fisheye
Ikelite Housing, 2 x DS160 Ikelite Strobes
f11, 1/250th, ISO 160
Christophe Mason-Parker

Page 107
BEAU VALLON, MAHÉ
Canon 7D, Tokina 10-17mm Fisheye
Ikelite Housing, 2 x DS160 Ikelite Strobes
f18, 1/100th, ISO 200
Christophe Mason-Parker

Pages 108–109
ALPHONSE ISLAND
Canon 7D, Tokina 10-17mm Fisheye
Ikelite Housing, 2 x DS160 Ikelite Strobes
f8, 1/160th, ISO 200
Christophe Mason-Parker

Pages 110–111
SHARK BANK
Canon 7D, Tokina 10-17mm Fisheye
Ikelite Housing, 2 x DS160 Ikelite Strobes
f8, 1/250th, ISO 200
Christophe Mason-Parker

Pages 112–113
ALPHONSE ISLAND
Canon 7D, Tokina 10-17mm Fisheye
Ikelite Housing, 2 x DS160 Ikelite Strobes
f8, 1/200th, ISO 200
Christophe Mason-Parker

Pages 114-115
BAIE TERNAY MARINE NATIONAL PARK, MAHÉ
Canon 7D, Tokina 10-17mm Fisheye
Ikelite Housing, 2 x DS160 Ikelite Strobes
f10, 1/200th, ISO 200
Christophe Mason-Parker

Page 116
BEAU VALLON, MAHÉ
Canon 7D, Canon 50mm
Ikelite Housing, 2 x DS160 Ikelite Strobes
f16, 1/160th, ISO 250
Christophe Mason-Parker

Page 117
ANSE A LA MOUCHE, MAHÉ
Canon 50D, Tokina 10-17mm Fisheye
Ikelite Housing, 1 x DS161 Strobe
f9, 1/100th, ISO 200
Joe Daniels

Pages 118–119
ALPHONSE ISLAND
Canon 7D, Tokina 10-17mm Fisheye
Ikelite Housing, 2 x DS160 Ikelite Strobes
f8, 1/250th, ISO 160
Christophe Mason-Parker

Pages 120–121
SHARK BANK
Canon 7D, Tokina 10-17mm Fisheye
Nauticam Housing, 2 x Sea&Sea YSD1 Strobes
f6.3, 1/125th, ISO 100
Joe Daniels

Page122
BEAU VALLON, MAHÉ
Canon 7D, Tokina 10-17mm Fisheye
Ikelite Housing, 2 x DS160 Ikelite Strobes
f8, 1/200th ISO 200
Christophe Mason-Parker

Page 123
L'ILOT
Canon 7D, 100mm macro
Nauticam Housing, 2 x Sea&Sea YSD1 Strobes
f8, 1/200th, ISO 200
Joe Daniels

Page 124
BOOBY ISLAND
Canon 7D, Canon 100mm macro
Ikelite Housing, 2 x DS160 Ikelite Strobes
f18, 1/250th, ISO 160
Christophe Mason-Parker

SHOOTING EDEN

Page 125
BRISSAIRE ROCKS
Canon 7D, 100mm macro
Nauticam Housing, 2 x Sea&Sea YSD1 Strobes
f11, 1/160th, ISO 100
Joe Daniels

Page 126
BAIE TERNAY MARINE NATIONAL PARK, MAHÉ
Canon 50D, Tokina 10-17mm Fisheye
Ikelite Housing, 2 x DS161 Strobe
f11, 1/125th, ISO 100
Joe Daniels

Page 127
DRAGON'S TEETH, MAHÉ
Canon 7D, 100mm macro
Nauticam Housing
f8, 1/200th, ISO 100
Joe Daniels

Pages 128–129
ALPHONSE ISLAND
Canon 7D, Tokina 10-17mm Fisheye
Ikelite Housing, 2 x DS160 Ikelite Strobes
f8, 1/160th, ISO 160
Christophe Mason-Parker

Page 130
ANSE SOULIAC, MAHÉ
Canon 50D, Tokina 10-17mm Fisheye
Ikelite Housing, 1 x DS161 Strobe
f16, 1/100th, ISO 100
Joe Daniels

Page 131
GLACIS, MAHÉ
Canon 7D, Tokina 10-17mm Fisheye
Ikelite Housing, 2 x DS160 Ikelite Strobes
f18, 1/10th, ISO 125
Christophe Mason-Parker

Page 132
ST FRANÇOIS ATOLL
Canon 7D, Tokina 10-17mm Fisheye
Ikelite Housing, 2 x DS160 Ikelite Strobes
f8, 1/200th, ISO 160
Christophe Mason-Parker

Page 133
BEAU VALLON, MAHÉ
Canon 7D, Canon 50mm
Ikelite Housing, 2 x DS160 Ikelite Strobes
f16, 1/200th, ISO 125
Christophe Mason-Parker

Page 134
BEAU VALLON, MAHÉ
Canon 7D, Canon 100mm macro
Ikelite Housing, 2 x DS160 Ikelite Strobes
f11, 1/250th, ISO 200
Christophe Mason-Parker

215

SHOOTING EDEN

Page 135
BAIE TERNAY MARINE NATIONAL PARK, MAHÉ
Canon 7D, 100mm macro
Nauticam Housing, 2 x Sea&Sea YSD1 Strobes
f22, 1/160th, ISO 100
Joe Daniels

Pages 136–137
FRÉGATE ISLAND
Canon 7D, Tokina 10-17mm Fisheye
Nauticam Housing, 2 x Sea&Sea YSD1 Strobes
f9, 1/160th, ISO 200
Joe Daniels

Pages 138–139
BEAU VALLON, MAHÉ
Canon 7D, Tokina 10-17mm Fisheye
Ikelite Housing, 2 x DS160 Ikelite Strobes
f13, 1/160s, ISO 200
Christophe Mason-Parker

Page 140
BEAU VALLON, MAHÉ
Canon 50D, Canon 60mm macro
Ikelite Housing, 1 x DS161 Strobe
f11, 1/125th, ISO 100
Joe Daniels

Pages 142–143
BEAU VALLON, MAHÉ
Canon 7D, Canon 100mm macro
Ikelite Housing, 2 x DS160 Ikelite Strobes
f8, 1/200th, ISO 160
Christophe Mason-Parker

Page 144
CERF ISLAND
Canon 7D, Canon 50mm
Ikelite Housing, 2 x DS160 Ikelite Strobes
f8, 1/160th, ISO 160
Christophe Mason-Parker

Page 146
BAIE TERNAY MARINE NATIONAL PARK, MAHÉ
Canon 50D, Canon 60mm macro
Ikelite Housing, 1 x DS161 Strobe
f10, 1/125th, ISO 100
Joe Daniels

Page 147
BEAU VALLON, MAHÈ
Canon 7D, 100mm macro, SubSee +10 dioptre
Nauticam Housing, 2 x Sea&Sea YSD1 Strobes
f22, 1/250th, ISO 100
Joe Daniels

Pages 148–149
L'ILOT
Canon 7D, Canon 100mm macro
Ikelite Housing, 2 x DS160 Ikelite Strobes
f14, 160th, ISO 160
Christophe Mason-Parker

216

SHOOTING EDEN

Page 150
BAIE TERNAY MARINE NATIONAL PARK, MAHÉ
Canon 7D, 100mm macro
Nauticam Housing, 2 x Sea&Sea YSD1 Strobes
f8, 1/200th, ISO 100
Joe Daniels

Page 151
L'ILOT
Canon 7D, 100mm macro, SubSee +10 dioptre
Nauticam Housing, 2 x Sea&Sea YSD1 Strobes
f8, 1/80th, ISO 200
Joe Daniels

Page 152
BEAU VALLON, MAHÉ
Canon 7D, 100mm macro, SubSee +10 dioptre
Nauticam Housing, 2 x Sea&Sea YSD1 Strobes
f8, 1/250th, ISO 100
Joe Daniels

Page 153
BAIE TERNAY MARINE NATIONAL PARK, MAHÉ
Canon 7D, 100mm macro
Nauticam Housing, 2 x Sea&Sea YSD1 Strobes
f22, 1/250th, ISO 200
Joe Daniels

Page 154
BAIE TERNAY MARINE NATIONAL PARK, MAHÉ
Canon 50D, Canon 60mm macro
Ikelite Housing, 1 x DS161 Strobe
f10, 1/125th, ISO 100
Joe Daniels

Page 155
L'ILOT
Canon 7D, 100mm macro
Nauticam Housing, 2 x Sea&Sea YSD1 Strobes
f13, 1/125th, ISO 200
Joe Daniels

Pages 156–157
BEAU VALLON, MAHÉ
Canon 50D, Canon 60mm macro
Ikelite Housing, 1 x DS161 Strobe
f22, 1/125th, ISO 100
Joe Daniels

Page 158
DRAGON'S TEETH, MAHÉ
Canon 7D, 100mm macro
Nauticam Housing, 2 x Sea&Sea YSD1 Strobes
f10, 1/125th, ISO 100
Joe Daniels

Page 159
BEAU VALLON, MAHÉ
Canon 50D, Tokina 10-17mm Fisheye
Ikelite Housing, 2 x DS161 Strobe
f8, 1/125th, ISO 200
Joe Daniels

217

SHOOTING EDEN

Pages 160–161
BAIE TERNAY MARINE NATIONAL PARK, MAHÉ
Canon 7D, Tokina 10-17mm Fisheye
Ikelite Housing, 2 x DS160 Ikelite Strobes
f10, 1/200th, ISO 200
Christophe Mason-Parker

Page 162
ANSE A LA MOUCHE, MAHÉ
Canon 50D, Tokina 10-17mm Fisheye
Ikelite Housing, 2 x DS161 Strobe
f13, 1/100, ISO 100
Joe Daniels

Page 163
BEAU VALLON, MAHÉ
Canon 7D, 100mm macro, SubSee +10 dioptre
Nauticam Housing, 2 x Sea&Sea YSD1 Strobes
f14, 1/250th, ISO 160
Joe Daniels

Pages 164-165
CURIEUSE ISLAND MARINE NATIONAL PARK
Canon 7D, Canon 10-18mm,
f14, 1/100th, ISO 160
Christophe Mason-Parker

Pages 166–167
BAIE TERNAY MARINE NATIONAL PARK, MAHÉ
Canon 7D, Tokina 10-17mm Fisheye
Ikelite Housing, 2 x DS160 Ikelite Strobes
f18, 1/160th, ISO 250
Christophe Mason-Parker

Page 168
ARIDE ISLAND
Canon 50d, 70-200mm
f5.6, 1/400th, ISO 500
Joe Daniels

Page 169
COUSIN ISLAND
Canon 550D, Tokina 10-17mm Fisheye
f18, 1/100th, ISO 200
Christophe Mason-Parker

Page 170
ANSE SOULIAC, MAHÉ
Canon 50D, Tokina 10-17mm Fisheye
Ikelite Housing, 2 x DS161 Strobes
f10, 1/125th, ISO 400
Joe Daniels

Pages 172–173
BAIE TERNAY MARINE NATIONAL PARK, MAHÉ
Canon 50D, Tokina 10-17mm Fisheye
Ikelite Housing, 2 x DS161 Strobes
f10, 1/125th, ISO 100
Joe Daniels

SHOOTING EDEN

Page 175
BAIE TERNAY MARINE NATIONAL PARK, MAHÉ
Canon 50D, Tokina 10-17mm Fisheye
Ikelite Housing, 2 x DS161 Strobes
f16, 1/125th, ISO 100
Joe Daniels

Pages 176–177
BAIE TERNAY MARINE NATIONAL PARK, MAHÉ
Canon 50D, 10-22mm
Ikelite Housing, 1 x DS161 Strobe
f9, 1/125th, ISO 100
Joe Daniels

Page 178
BAIE TERNAY MARINE NATIONAL PARK, MAHÉ
Canon 50D, Tokina 10-17mm Fisheye
Ikelite Housing
f8, 1/125th, ISO 200
Joe Daniels

Page 179
BAIE TERNAY MARINE NATIONAL PARK, MAHÉ
Canon 7D, Tokina 10-17mm Fisheye
Nauticam Housing, 2 x Sea&Sea YSD1 Strobes
f8, 1/100th, ISO 100
Joe Daniels

Page 180
BAIE TERNAY MARINE NATIONAL PARK, MAHÉ
Canon 50D, Tokina 10-17mm Fisheye
Ikelite Housing, 2 x DS161 Strobes
f13, 1/100th, ISO 100
Joe Daniels

Page 181
ANSE SOULIAC, MAHÉ
Canon 50D, Tokina 10-17mm Fisheye
Ikelite Housing, 2 x DS161 Strobes
f14, 1/125th, ISO 100
Joe Daniels

Pages 182–183
BAIE TERNAY MARINE NATIONAL PARK, MAHÉ
Canon 7D, Tokina 10-17mm Fisheye
Ikelite Housing, 2 x DS160 Ikelite Strobes
f13, 1/125th, ISO 200
Christophe Mason-Parker

Pages 184–185
CURIEUSE ISLAND MARINE NATIONAL PARK
Canon 7D, Canon 10-18mm lens,
f11, 1/250th, ISO 250
Christophe Mason-Parker

Page 187
BAIE TERNAY MARINE NATIONAL PARK, MAHÉ
Canon 7D, Tokina 10-17mm Fisheye
Ikelite Housing, 2 x DS160 Ikelite Strobes
f14, 1/160th, ISO 200
Christophe Mason-Parker

219

Page 188
BAIE TERNAY MARINE NATIONAL PARK, MAHÉ
Canon 7D, Tokina 10-17mm Fisheye
Ikelite Housing, 2 x DS160 Ikelite Strobes
f14, 1/160th, ISO 200
Christophe Mason-Parker

Page 190
BAIE TERNAY MARINE NATIONAL PARK, MAHÉ
Canon 7D, Tokina 10-17mm Fisheye
Ikelite Housing, 2 x DS160 Ikelite Strobes
f8, 1/250th, ISO 160
Christophe Mason-Parker

Page 192
BEAU VALLON, MAHÉ
Canon 7D, Tokina 10-17mm Fisheye
Ikelite Housing, 2 x DS160 Ikelite Strobes
fll, 1/200th, ISO 200
Christophe Mason-Parker

Page 193
BEAU VALLON, MAHÉ
Canon 7D, Canon 100mm macro,
Ikelite Housing, 2 x DS160 Ikelite Strobes
f11, 1/250th, ISO 200
Christophe Mason-Parker

Pages 194–195
LITTLE FRÉGATE
Canon 7D, Tokina 10-17mm Fisheye
Ikelite Housing, 2 x DS160 Ikelite Strobes
f13, 1/160th, ISO 250
Christophe Mason-Parker

Page 196
CURIEUSE ISLAND MARINE NATIONAL PARK
Canon 7D, Tokina 10-17mm Fisheye
Ikelite Housing, 2 x DS160 Ikelite Strobes
f11, 1/160th, ISO 200
Christophe Mason-Parker

Page 197
CURIEUSE ISLAND MARINE NATIONAL PARK
Canon 7D, Tokina 10-17mm Fisheye
Ikelite Housing, 2 x DS160 Ikelite Strobes
F9, 1/160th, ISO 200
Christophe Mason-Parker

Page 198
PETITE ANSE, MAHÉ
Canon 7D, Tokina 10-17mm Fisheye
Ikelite Housing, 2 x DS160 Ikelite Strobes
f13, 1/250th, ISO 200
Christophe Mason-Parker

Page 199
BAIE TERNAY MARINE NATIONAL PARK, MAHÉ
Canon 7D, Tokina 10-17mm Fisheye
Ikelite Housing, 2 x DS160 Ikelite Strobes
f10, 1/200th, ISO 160
Christophe Mason-Parker

Page 200
ANSE ROYALE, MAHÉ
Canon 7d, Tokina 10-17mm
Nauticam Housing
f16, 1/160th, ISO 200
Joe Daniels

Page 201
CURIEUSE ISLAND MARINE NATIONAL PARK
Canon 7D, Tokina 10-17mm Fisheye
Ikelite Housing, 2 x DS160 Ikelite Strobes
f11, 1/160th, ISO 400
Christophe Mason-Parker

Pages 202–203
BRISSARE ROCKS, MAHÉ
Canon 7D, Tokina 10-17mm Fisheye
Ikelite Housing, 2 x DS160 Ikelite Strobes
f10, 1/160th, ISO 200
Christophe Mason-Parker

ACKNOWLEDGEMENTS

When we first conceived the idea of *Underwater Eden*, we were acutely aware that such a project would require the assistance of numerous individuals. What we were not prepared for was just how generous people were prepared to be in offering their time, resources and expertise to help us achieve our goals. We are extremely grateful to every one of them.

The two persons to whom we are most indebted are Emily Allen and Rowana Walton. They have been supportive throughout the journey, displaying levels of patience beyond anything one would think humanly possible. Their guidance, advice, hours of editing and unwavering encouragement have all been instrumental in helping to create the book you are reading today.

We would like to particularly thank Frégate Island Private and the Alphonse Island Resort, who provided substantial support beyond all our expectations. Their generosity enabled us to photograph coral reefs and document species that would otherwise have remained beyond our reach. So thank you Erin Gleeson, Janske van de Crommenacker, Martijn van Dinther, Lucy Martin, Sam Balderson and everyone else who made this possible.

To the scientists who provided invaluable input on the content, and to those who spent endless hours reviewing chapters, editing text and offering suggestions, we are extremely thankful for your contributions. In no particular order we would like to offer our sincere gratitude to Jeanne Mortimer, Jude Bijoux, Kirsty Nash, Lindsay Sullivan and Sonia Rowley.

In addition we would like to offer a special thanks to the Minister of Tourism, Civil Aviation, Ports and Marine, Mr Didier Dogley, for contributing the foreword for the book. The progressive approach currently being undertaken by his ministry offers hope for the future of the marine environment of Seychelles.

Finally to John Beaufoy and Rosemary Wilkinson of John Beaufoy Publishers, thank you for your backing and commitment to the production of *Underwater Eden*.

To anyone who has had the privilege to snorkel or dive on a coral reef in Seychelles, we hope that this book serves as a small reminder of the nation's incredible submarine world. And for those who are yet to visit these enchanted isles, perhaps the images on these pages will entice you to one day explore this underwater Eden.

ABOUT THE AUTHORS

Christophe Mason-Parker For almost a decade Chris has called Seychelles his home. Having first arrived in the island nation back in 2009, he was immediately captivated by its incredible beauty. Chris has harboured a fascination for the marine environment since a young age, and before settling in Seychelles he worked for several environmental NGOs in different locations around the globe. A passionate conservationist, Chris is the co-founder of Sea Turtle Friends Seychelles, a NGO responsible for promoting education and awareness of marine turtles. Through his photography he tries to highlight crucial conservation issues, and his articles and images have appeared in numerous international publications. He has collaborated on several scientific research papers, and in 2015 he co-authored his first book, *Underwater Guide to Seychelles*. Today, Chris oversees a variety of research projects in Seychelles for Global Vision International. In his spare time he continues to photograph the amazing flora and fauna of the Seychelles archipelago. A selection of his images can be found on his website at www.archipelagoimages.net.

Joe Daniels Joe first visited Seychelles in 2007 while volunteering with Global Vision International on its marine conservation expedition. During this time he became fascinated with using his camera to capture the underwater world. Every minute he wasn't conducting scientific marine surveys, Joe was freediving in the waters around the inner islands. His love of underwater photography was further developed during his travels through New Zealand, South Africa, Australia, Mexico and Indonesia. Every new country was a new opportunity to capture images of unique species and habitats. Seychelles was never far from his thoughts, and Joe took the opportunity to return to the archipelago in 2010 to assist Marine Conservation Society Seychelles with its Whale Shark research and again in 2011 as Dive Officer for Global Vision International. Joe had the chance to focus on his photography when he moved to Indonesia in 2013 to manage a photography-orientated diving resort. Since then he has won numerous awards, and has had his work published in national and international publications. Now based in the south of France, Joe is able to spend his time exploring the cooler (but no less fascinating) waters of Europe in between photography trips. To see more of Joe's work visit www.jldaniels.co.uk

FIRST PUBLISHED IN THE UNITED KINGDOM IN 2018 BY JOHN BEAUFOY PUBLISHING,
11 BLENHEIM COURT, 316 WOODSTOCK ROAD, OXFORD OX2 7NS, ENGLAND
WWW.JOHNBEAUFOY.COM

1 3 5 7 9 10 8 6 4 2

COPYRIGHT © 2018 JOHN BEAUFOY PUBLISHING LIMITED
COPYRIGHT © 2018 IN TEXT CHRISTOPHE MASON-PARKER AND JOE DANIELS
COPYRIGHT © IN PHOTOGRAPHS, CHRISTOPHE MASON-PARKER AND JOE DANIELS (SEE PAGES 206–221)
COPYRIGHT © 2018 IN CARTOGRAPHY JOHN BEAUFOY PUBLISHING LIMITED

ALL RIGHTS RESERVED. NO PART OF THIS PUBLICATION MAY BE REPRODUCED, STORED IN A RETRIEVAL SYSTEM
OR TRANSMITTED IN ANY FORM OR BY ANY MEANS, ELECTRONIC, MECHANICAL, PHOTOCOPYING, RECORDING OR
OTHERWISE, WITHOUT THE PRIOR WRITTEN PERMISSION OF THE PUBLISHERS AND COPYRIGHT HOLDERS.

GREAT CARE HAS BEEN TAKEN TO MAINTAIN THE ACCURACY OF THE INFORMATION CONTAINED IN THIS WORK.
HOWEVER, NEITHER THE PUBLISHERS NOR THE AUTHOR CAN BE HELD RESPONSIBLE FOR ANY CONSEQUENCES ARISING
FROM THE USE OF THE INFORMATION CONTAINED THEREIN.

ISBN 978-1-909612-97-6

DESIGNED BY GLYN BRIDGEWATER
EDITED BY KRYSTYNA MAYER
CARTOGRAPHY BY WILLIAM SMUTS
PROJECT MANAGEMENT BY ROSEMARY WILKINSON

PRINTED AND BOUND IN MALAYSIA BY TIMES OFFSET (M) LTD